Face Off

How to Draw Amazing Caricatures & Comic Portraits

Harry Hamernik

IMPACT

Cincinnati, Ohio

www.impact-books.com

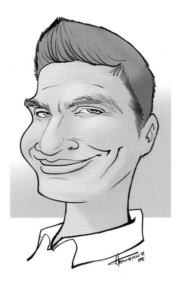

Other fine Impact Books are available from your local book-store, art supply store or direct from the publisher.

10 09 08 07 06 5 4 3 2 1

DISTRIBUTED IN CANADA BY FRASER DIRECT
100 Armstrong Avenue
Georgetown, ON, Canada L7G 5S4
Tel: (905) 877-4411

DISTRIBUTED IN THE U.K. AND EUROPE BY DAVID & CHARLES
Brunel House, Newton Abbot, Devon, TQ12 4PU, England
Tel: (+44) 1626 323200, Fax: (+44) 1626 323319
Email: mail@davidandcharles.co.uk

DISTRIBUTED IN AUSTRALIA BY CAPRICORN LINK
P.O. Box 704, S. Windsor NSW, 2756 Australia
Tel: (02) 4577-3555

Library of Congress Cataloging-in-Publication Data
Hamernik, Harry
Face off : how to draw amazing caricatures & comic portraits / Harry Hamernik.
 p. cm.
Includes index.
ISBN-13: 978-1-58180-759-2 (pbk. : alk. paper)
ISBN-10: 1-58180-759-7 (pbk. : alk. paper)
1. Portraits--Caricatures and cartoons. 2. Cartooning--Technique. I. Title.

NC1763.P677H36 2006
741.5'1--dc22 2006013135

Edited by Christina Xenos
Designed by Guy Kelly
Production art by Amy Wilkin
Production coordinated by Matt Wagner

ABOUT THE AUTHOR

Harry Hamernik has spent eight years teaching caricature drawing to artists for theme parks such as SeaWorld, LEGOLAND, Knott's Berry Farm and Paramount's Kings Island. Currently, he is a full-time faculty member at the Art Institute of California in San Diego, where he teaches drawing courses in the animation program. Additionally, he has taught at the Art Academy of Los Angeles and Orange County Art Studios. Harry holds a Bachelor of Arts degree in graphic design with an emphasis in commercial illustration. He and his wife, Kate, also own a freelance art business. Harry is available for hire as a caricature or freelance artist for any event or project. For more information, go to www.hamernikartstudios.com.

ACKNOWLEDGMENTS

I would like to recognize and acknowledge all the individuals who helped me in the creation of this book. Thank you to my wife, Kate, who kept me motivated through the entire process. Thank you to Pamela Wissman, acquisitions editor at F+W Publications, Inc., who gave me the chance to create this book. Thank you to my editor, Christina Xenos, who worked with me patiently through the deadlines. Thank you to all my friends who modeled for this book. Thanks to Kaman's Art Shoppes and Steve Fishwick, who employed me as a caricature artist all those years where I practiced this craft. "Sorry it took so long" goes out to all my past students who have been waiting for this book for many years. Lastly, thank you to my parents, who let me pursue art as a career.

DEDICATION

To Kate—
Everything in my life is better because of you!

Metric Conversion Chart

To convert	to	multiply by
Inches	Centimeters	2.54
Centimeters	Inches	0.4
Feet	Centimeters	30.5
Centimeters	Feet	0.03
Yards	Meters	0.9
Meters	Yards	1.1
Sq. Inches	Sq. Centimeters	6.45
Sq. Centimeters	Sq. Inches	0.16
Sq. Feet	Sq. Meters	0.09
Sq. Meters	Sq. Feet	10.8
Sq. Yards	Sq. Meters	0.8
Sq. Meters	Sq. Yards	1.2

contents

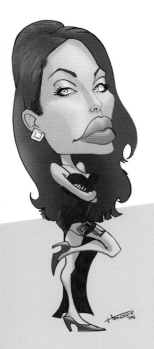

Introduction
4

Materials and Supplies
6

Marker Techniques
8

Pencil Techniques
10

Colored Pencil Techniques
12

Computer Coloring
18

Front-View Caricatures
22

¾-View Caricatures
64

Profile Caricatures
98

Celebrity Gallery
120

Closing Comments
125

Index
126

introduction

Drawing comic portraits or caricatures is a whole lot of fun. How else can you get paid to poke fun at people? Of course, it's all in good taste and for everyone's entertainment. Caricature artists are entertainers, not comedians; if you learn this right away, it will save you a lot of trouble.

Having trained many artists for theme parks, I finally figured out that it was easier on everyone if I could distribute handouts of the points I was making during my demonstrations. Those handouts piled up until I put them together for this book. Explore this book, following all the instructions so you can make your own fun caricatures and maybe even teach those theme park artists a thing or two.

First, a few suggestions:

1 **Proceed page by page, and don't skip around the book. It will all make more sense this way.**

2 **Learn the techniques first. Then you can try drawing people in person.**

3 **Don't be afraid of mistakes. With quick caricatures drawn live, there will always be some mistakes on the page.** A good caricature artist can draw the sketch quickly, create a likeness and make few mistakes. Most mistakes are so subtle that no one will notice them.

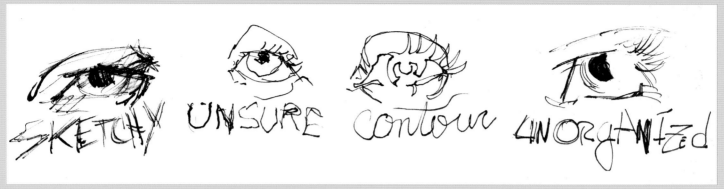

THE MARKS OF AN AMATEUR

At first, the lines in your caricatures may look like these. Avoid marks that are sketchy, unsure, contour-like or unorganized. Every mark left on the page should look good all by itself.

MAKE YOUR MARK WITH MARKER

I recommend drawing with a marker. This will help break the habit of timid sketching when confident marks are what you want.

DRAW ANYTHING AND EVERYTHING

This is the first exercise you should do with your marker or pencil: Draw shapes and objects, focusing on creating sketches that are visually appealing. The marks you leave should be fun, interesting, bold and pleasing.

Materials and Supplies

When creating caricatures, the most important tools you'll use are paper, markers, pencils and colored pencils. Some art products can become discontinued, so if you find something you like, buy a bunch of it.

Paper

You're going to use a lot of paper, so you might as well save some money. Try 11" x 17" (28cm x 43cm) photocopy paper, available at any office supply store. It comes in reams of five hundred sheets. You can save more money by buying it by the box. Paper is rated by its weight and brightness. Buy the heaviest and brightest paper you can afford. Buy one ream first to test the paper, making sure it works well with markers, pencils and colored pencils before you invest in an entire box.

PAPER
Photocopy paper is fine for caricature drawing, especially if you're new at it.

Markers

Marker drawing is esteemed as one of the most difficult ways to draw because you can't erase. Markers are versatile and dry instantly, allowing you to work at a rapid pace. Look for markers with a pointed nib, preferably flexible. Some have very stiff tips that don't allow you to vary your lines. You need the ability to draw thick lines and thin lines, and to switch between the two without having to change markers. I prefer the Dixon Markette marker, currently one of the best on the market. You can purchase them on the Internet from office supply stores in Canada. However, try different kinds and brands to see which ones you like best.

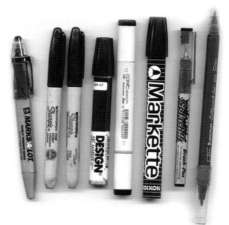

MY FAVORITE MARKERS
When you find a marker you like, buy as many as you can afford. The Dixon Markette is my favorite. I also like Copic Sketch marker (fourth from the right)—it is refillable, and you can buy a smaller nib tip for it (though this is hard to find). Try as many markers as you can. It's the only way to see if they work for you.

Marker Types

Alcohol-based markers dry out very quickly. Replacing them makes for an expensive hobby. Chemical-based markers give off smelly fumes that can be harmful if inhaled, but are the only other alternative. I use chemical-based markers only when I am working in a place with plenty of ventilation.

Pencils

When working in pencil, use a softer variety such as a 4B or 6B. The softer the pencil, the easier it will be to create both thin and thick marks and a dark line. Harder pencils make lighter, thinner marks, which are useful in certain instances. I like Staedler pencils for their consistency and because they don't smear much. Others

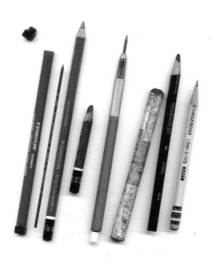

PENCILS
Here are a few of your options, including Staedler and Pris-macolor Black pencils of varying hardness. Also shown is the reliable Ticonderoga Soft pencil, a standard lead holder and a single lead stick, as well as a blending stump for shading your drawings. Round off the tip of the stump with fine sandpaper so you have a broad tip to work with.

Do-It-Yourself Lap Easel

The lap easel is the perfect tool for sketching in public. You can make this easel inexpensively out of parts from your local hardware store. To use it, just sit down and place the bottom of the drawing board on your lap. There are endless variations, but don't make it too big or heavy. The idea is for it to be portable and easy to work on, without being too unstable.

Supply List

- ✘ Drawing board. It should be lightweight but durable, of any size bigger than the paper.
- ✘ PVC irrigation pipes. These form the legs and crossbars. Use ¾-inch (19mm) or larger pipes. The length of the legs is up to you.
- ✘ Two 90° joints for the top crossbar.
- ✘ Two "T" PVC joints for the bottom crossbar.
- ✘ Three pipe straps. These will be in the electrical section of your hardware store and are used for attaching conduit pipes.
- ✘ 1" x 6" (3cm x 15cm) oak veneer. Use this on the back of the board, between the pipe straps and the drawing board. Otherwise, the screws you use to attach the pipe straps will poke out from the board.
- ✘ 1" x 2" (3cm x 5cm) oak paper bar. This bar is in front and holds the drawing paper to the board.
- ✘ Two long bolts. Make a hole through the drawing board and the paper bar. These bolts attach the paper bar to the drawing board.
- ✘ Two wing nuts. These will tighten the paper bar so the paper does not fall out.

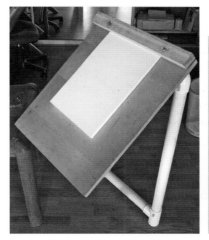
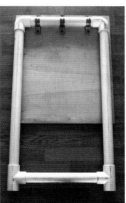
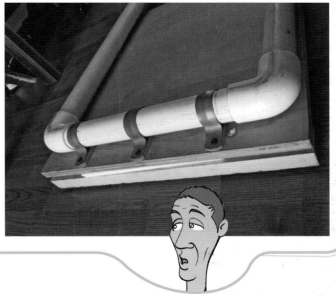

I recommend are Prismacolor Black pencils and the Ticonderoga Soft pencil. (You cannot erase the Prismacolor, though.) You can also buy lead for a leadholder pencil. Again, test different types and brands. A blending stump is useful for shading your drawings.

Colored Pencils

I use Prismacolor colored pencils. The brand isn't that important, but, in my opinion, this brand is a better quality than the others. I have used the following palette for many years without the need for more colors: Black, Blush, Burnt Ochre, Burnt Umber, Canary Yellow, Copenhagen Blue, Flesh, Forest Green, Gray, Green Bice, Orange, Pink, Raw Sienna, Raw Umber, Scarlet Lake, Sky Blue, Terra Cotta, True Blue, Ultramarine Blue, Violet and Yellow Ochre. Color names may vary from brand to brand.

Pencil Sharpener

You will need a good pencil sharpener when you sketch. A battery-operated one works best. Otherwise, pick up the best manual pencil sharpener you can find. Cheap ones will dull quickly.

COLORED PENCILS
I use Prismacolor colored pencils.

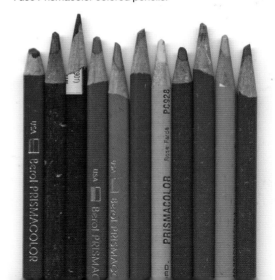

Marker Techniques

The best way to practice with a marker is to use the same one all the time. Get a marker and do all your writing with it. To practice using a marker for caricatures, memorize the basic line patterns used for each feature. Once you memorize the patterns, draw hundreds of versions of each feature. After reading about how to draw front-view caricatures starting on page 22, practice your marker techniques some more. Try to draw each facial feature with as few strokes as possible.

Avoid End Dots and Fuzzy Lines

If your marker is touching the page, ink will keep coming out, which explains those ink dots at the ends of your lines. You must draw without hesitation and pick up your pen quickly at the end of each stroke. If you are getting fuzzy lines, you are moving your pen too slowly.

PRACTICE MAKING LINES WITH MARKERS
At first, your marker lines may look like this—unsure and uncontrolled, with bleed dots, fuzzy lines and so forth. That's OK. The more of these kinds of sketches you do, the sooner you will get them out of your system.

 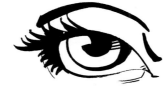 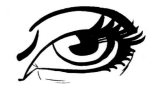

TRY GEOMETRIC SHAPES

Practice drawing each facial feature as a geometric shape. This is a great way to practice variations for each feature. Make some wide and others tall, or even an entirely different shape.

TURN GEOMETRIC SHAPES INTO FEATURES

When you get tired of drawing geometric shapes, try turning them into features. The shape will tell you what to draw, so you can focus on your line quality.

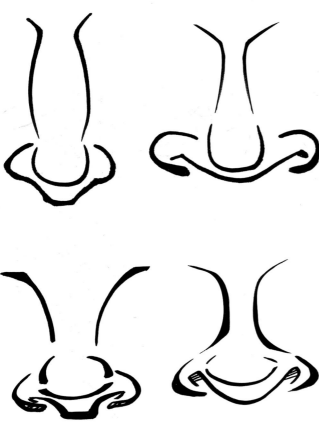

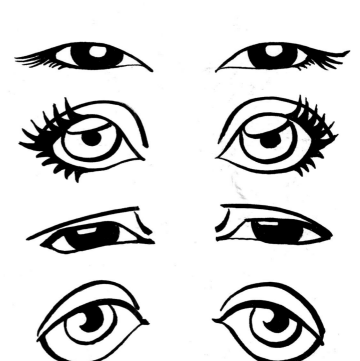

EXAGGERATE

When you first start practicing, try to exaggerate as much as you can. When you draw live, you will be looking for subtle differences in features. By knowing what types of exaggerations work for you, it will be a lot easier to see those differences.

PRACTICE VARIATIONS

Fill an entire page with variations of each feature. By studying one feature at a time, you will learn how to avoid drawing the same eyes on everyone, and so on. To create variety, study how to use anchor and pivot points on page 26.

Pencil Techniques

I recommend working with markers when you first begin doing caricatures; however, most of us are accustomed to using pencils and have it in our nature to sketch with them. The trouble with pencils is that we often put too many lines on the paper, and the drawings get messy. By working with markers, you will learn to put down fewer strokes. For those of you who prefer pencil, follow the same guidelines for working with markers as well as those included here.

SHAPE YOUR LEAD
Shape the tip of your pencil lead by rubbing it back and forth on a scrap sheet of paper until you have an angled flat spot on the tip. The flat spot lets you draw the thick lines. Spin the pencil around and draw with the tip to get thin lines.

PRACTICE LINE VARIATION
Draw thick, medium and thin lines. You will have to resharpen the tip often on a separate sheet of paper.

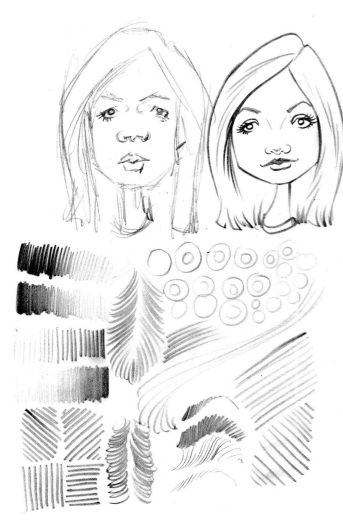

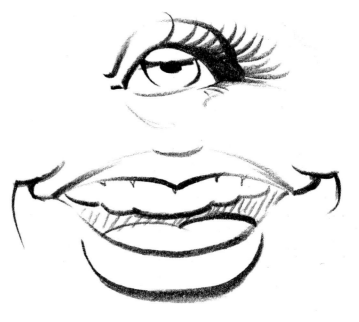

AVOID MESSY AND UNORGANIZED DRAWINGS
See how the face above on the right looks more professional? Every line is intentional and clearly made. Practice drawing strokes in every direction with straight and curved lines. Vary the pressure on your pencil and the spacing between your marks. Be bold with your lines.

DRAW FEATURES DECISIVELY
Draw features as cleanly and precisely as possible, avoiding "sketching" as much as you can. Think like a calligraphy artist—you only get one chance to do it right. Notice how these features are not quite as clean as the marker versions.

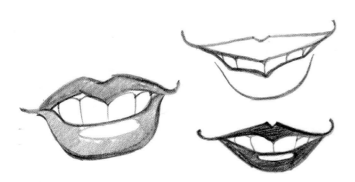

WORKING WITH VALUE

Using pencil gives you the opportunity to add different values or shading to each feature. By applying more pressure on your pencil, you can darken features to suggest enhancements such as lipstick, for example.

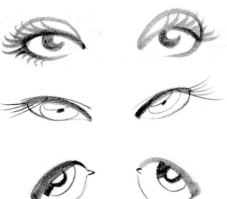

USING VARIED LINES

Practice drawing line variations within each feature. A thick line will only look thick if there is a thin line nearby to balance it.

SHADING YOUR SKETCH

Use your sanded blending stump to shade each sketch. Shade the exact same areas on every face. Shading should take you less than a minute. Notice how easily you can recognize a face with shading done this way.

SHAPING PENCIL TIPS AND BLENDING STUMPS

On the left is what your pencil tip should look like when shaped to make both thick and thin lines. In the center is a blending stump; on the right is how the stump should look after you sand the tip to prepare it for use.

Colored Pencil Techniques

Coloring a good drawing makes it great, but coloring a bad drawing makes it a colored bad drawing. Coloring does not cover up mistakes, so practice your caricatures until you are confident about your lines. Then begin coloring.

Coloring a caricature of a face should not take longer than one or two minutes. Definitely don't take more time to color than you did to draw the sketch. Your subject will get tired and uncomfortable very quickly, so you have to work fast. As in the drawing part of the process, there will be small mistakes made in the coloring process. It's part of the quick-sketch look. Don't worry about it, but try to color inside the lines as much as possible. Always color lightest to darkest, because you can always make an image darker, but you can't make an image lighter.

THE COLORS I USE IN MY PALETTE

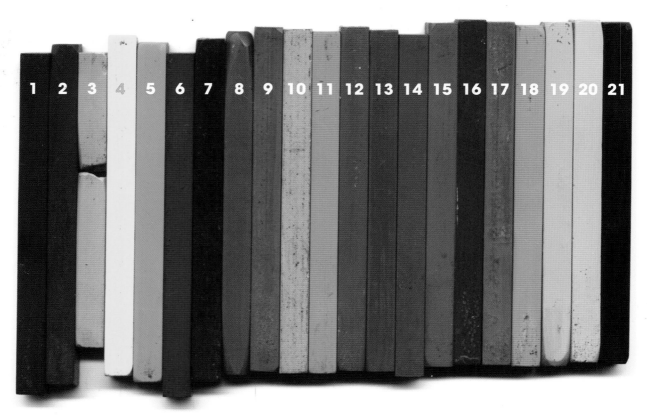

1 Forest Green	8 Raw Umber	15 Scarlet Lake
2 Burnt Umber	9 True Blue	16 Violet
3 Yellow Ochre	10 Sky Blue	17 Gray
4 Canary Yellow	11 Orange	18 Pink
5 Green Bice	12 Terra Cotta	19 Flesh
6 Copenhagen Blue	13 Raw Sienna	20 Blush
7 Ultramarine Blue	14 Burnt Ochre	21 Black

EYE COLORS

Use these samples as a guide for selecting the correct eye color for your subject.

| Sky Blue | Yellow Ochre + Sky Blue | Sky Blue + Raw Umber | Yellow Ochre + Green Bice | Raw Umber | Raw Umber + Terra Cotta | Burnt Umber |

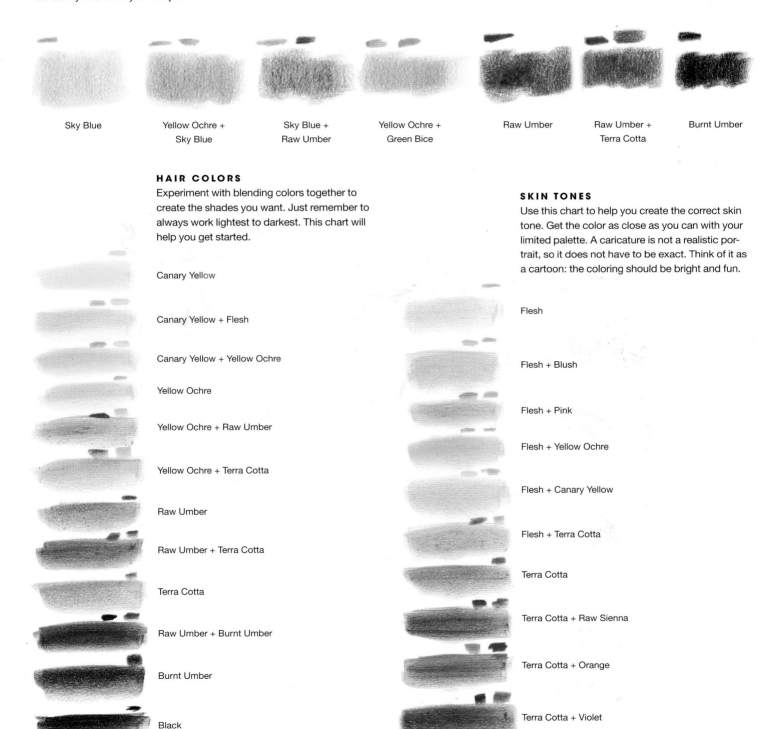

HAIR COLORS

Experiment with blending colors together to create the shades you want. Just remember to always work lightest to darkest. This chart will help you get started.

Canary Yellow

Canary Yellow + Flesh

Canary Yellow + Yellow Ochre

Yellow Ochre

Yellow Ochre + Raw Umber

Yellow Ochre + Terra Cotta

Raw Umber

Raw Umber + Terra Cotta

Terra Cotta

Raw Umber + Burnt Umber

Burnt Umber

Black

SKIN TONES

Use this chart to help you create the correct skin tone. Get the color as close as you can with your limited palette. A caricature is not a realistic portrait, so it does not have to be exact. Think of it as a cartoon: the coloring should be bright and fun.

Flesh

Flesh + Blush

Flesh + Pink

Flesh + Yellow Ochre

Flesh + Canary Yellow

Flesh + Terra Cotta

Terra Cotta

Terra Cotta + Raw Sienna

Terra Cotta + Orange

Terra Cotta + Violet

Using the Pattern Technique

These two pages will show you the pattern to use when coloring. To avoid spending too much time coloring, color every face using the same pattern. Every extra minute is an eternity for the person you are drawing.

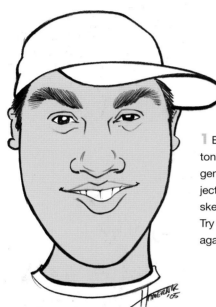

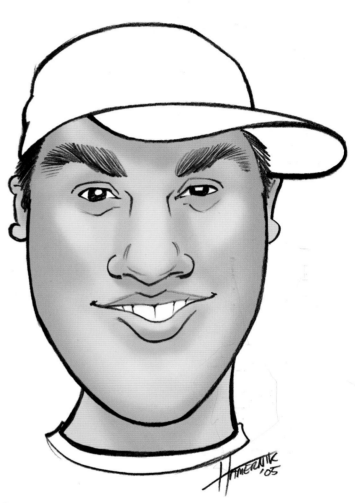

1 Begin with the overall skin tone. Choose the color that generally matches your subject. Color every part of the sketch that needs that color. Try not to pick up that color again as you continue.

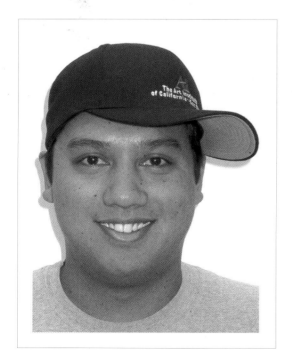

Our Model

2 Overlay another color to adjust the skin tone to better match your subject's. Use pressure to darken the shadow areas of the face. Your shadows need to be in the same places on every person; darken the sides of the face, under the chin and anywhere where a shadow would appear if there was an overhead light. Note that you are creating the shadows with the flesh-color values, not with black or gray.

Creating Highlights

For highlights in the skin tone, let the white of the paper show through some instead of heavily covering the area with color.

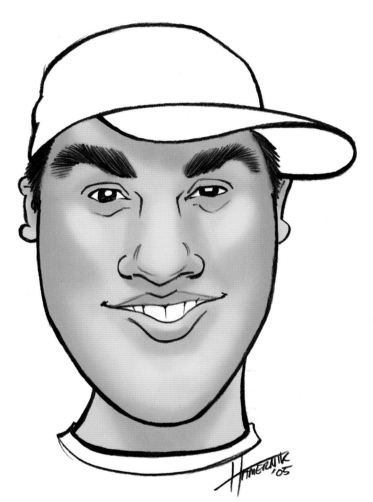

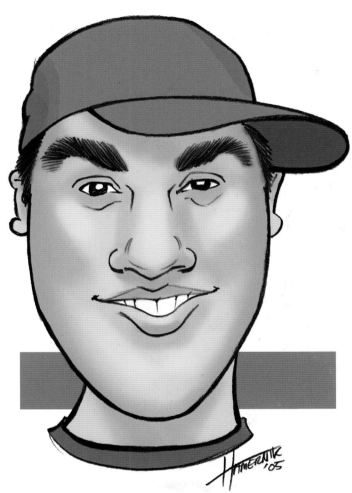

3 Add the hair color. You should already have most of the details in place at this point so that all you need to do is color the hair with some simple shading.

4 Add the eye color. After you finish coloring the eyes, color any items of clothing that you drew. Finish with the background. Keep the background simple—spend no more than ten seconds on it.

Coloring a Face With Colored Pencils

Colored pencils are the least expensive and the fastest way to add color. When using them, be very aware of how much time you are spending coloring. Use as few pencils as possible. Caricatures are about the sketch, not the color.

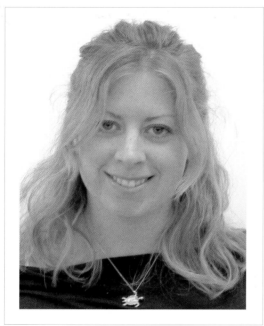

Our Model

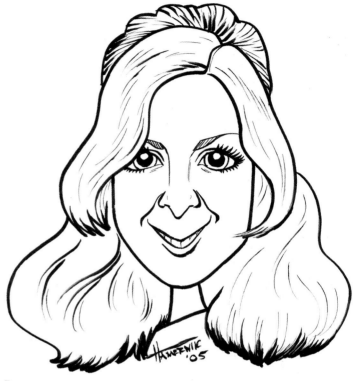

1 Complete your sketch. Avoid going back to drawing at this point.

2 Fill in the general skin tone as described in the pattern technique on page 14. The easiest way is to color from the top down. Avoid leaving streaks across the sketch by coloring in circles, using the broadest part of the pencil. Leave highlight areas as you color by using a lighter hand in these spots. Darken the shadow areas.

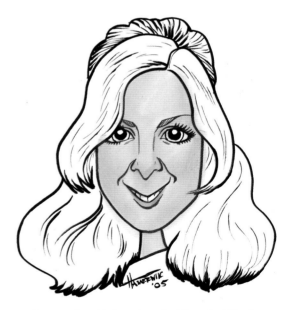

3 Add any color over the skin tone to adjust it so that it's closer to the model's actual skin tone. This should be so subtle that you can't actually distinguish the new color from the general skin tone. The overall appearance should be a blend of the two colors. Using the skin tone color, darken the shadow areas (see page 14, step 2).

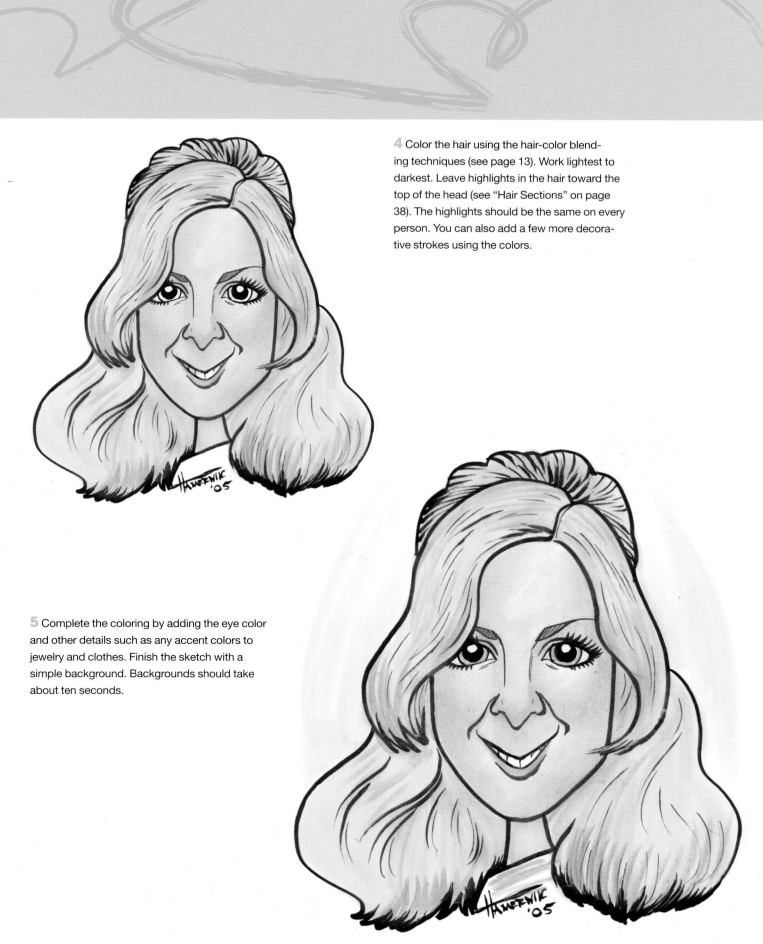

4 Color the hair using the hair-color blending techniques (see page 13). Work lightest to darkest. Leave highlights in the hair toward the top of the head (see "Hair Sections" on page 38). The highlights should be the same on every person. You can also add a few more decorative strokes using the colors.

5 Complete the coloring by adding the eye color and other details such as any accent colors to jewelry and clothes. Finish the sketch with a simple background. Backgrounds should take about ten seconds.

Computer Coloring

The information given here is for those of you who have Adobe® Photoshop CS® for Windows and have used it before. It is not intended for individuals who have never used this software. Here, I describe the basic process for coloring line art in Adobe® Photoshop®. Please experiment and add to this process based on what you know about Photoshop®.

Preparing the Image

1 Save the sketch file onto your hard drive.

2 Rotate your canvas so that the image is correct side up (Menu Bar> Image> Rotate Canvas).

3 Convert to Grayscale mode (Menu Bar> Image> Mode> Grayscale).

4 Adjust your line art. Use levels (Menu Bar> Image> Adjustments> Auto Levels).

5 Convert to RGB mode (Image> Mode> RGB).

6 Copy the Background layer on the Layers palette by dragging the background layer over the Create New Layer icon located on the bottom of the Layers palette, second from the right.

7 Rename the new layer "Line Art," and rename the background layer "Color."

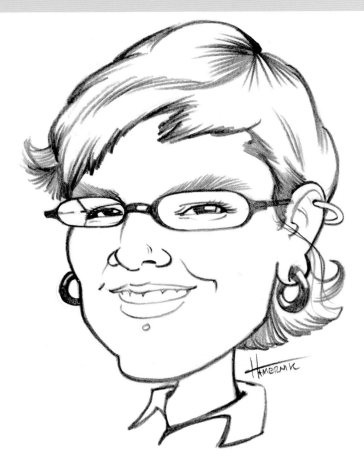

Our Model

1 Scan in your artwork at 300 DPI using the RGB mode or color image function of your scanner. If your sketch is too large to fit on the scanner, try taking a digital picture of it using the highest quality settings of your digital camera. Save the file as a JPEG file. Then open the sketch in Photoshop®.

2 On the Layers palette, change the Line Art layer's mode from Normal to Multiply.

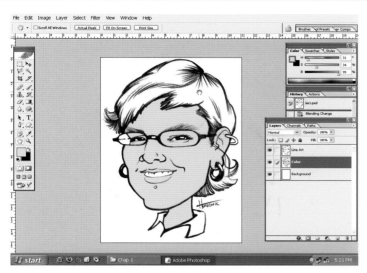

A Word of Advice About the Wand

When you get to step 3, if the wand selects too much of the sketch—rather than the isolated area you want to color—there is probably a break in the line somewhere. The wand only works if your lines make complete shapes. Are there any breaks in the outline of the shape you're trying to color? Then correct the original sketch and rescan it.

3 Use the wand tool (press "W" on your keyboard to select it) to select an area to color. Have "Anti-Aliased" and "Contiguous" selected in the wand's preferences tool bar. Don't select "Use All Layers." Choose a color to use from your color swatches. Then click to select an area to color. Slightly expand that selection (Menu Bar> Select> Modify> Expand> 2 Pixels). Press Alt + Delete to fill your area with color.

4 Select the brush tool (press "B" on the keyboard). Under the menu bar in the Brush preferences tool bar, on the left side next to the word "Brush," there is a dot with a number under it. Click on the number. This opens up this options window. The Master Diameter is the size of the brush and the Hardness is the fuzziness of the brush. A hardness of 100 percent means crisp edges, while 0 percent hardness means soft edges. Correct any parts of the sketch that were colored by mistake, using the brush. Choose the correct color from the color swatches.

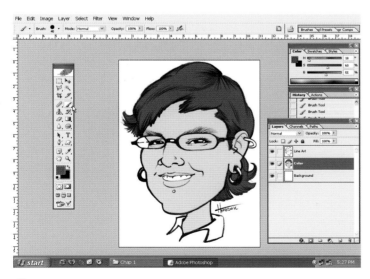

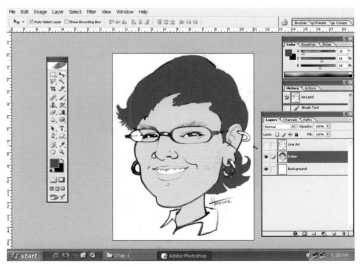

5 Use the technique described in step 3 to fill in the hair section. Make any corrections using the brush as described in step 4.

6 Turn off the Line Art layer (click on the eye icon in the Layers palette) to see what you are actually coloring. By using this technique, your original drawing is protected on its own layer. This way, you color behind it, and you don't mess up your original sketch.

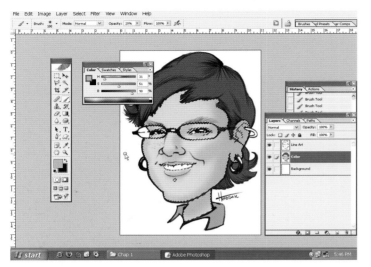

7 Turn on the Line Art layer. Select the Color layer. Use the wand to select the skin tone. All of the skin tone should be selected. Using the Color palette instead of the Swatches palette, select a darker version of the skin tone. Under the red "X" close box in the Color palette, there is a black Options arrow; click on it and select "HSB Sliders." The "H" is for hue or color, the "S" is saturation, and the "B" is brightness. Slide the "B" to get a darker version of the skin tone. Use the brush with 20 percent hardness and paint all the shadows. Now select a lighter version of the skin tone and do the same for the highlight areas.

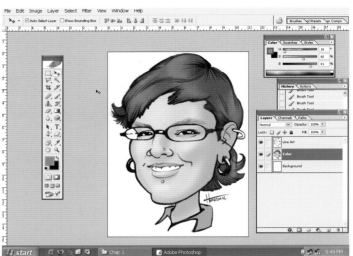

8 Add shadows and highlights to the hair the same way you added shadows and highlights to the face in step 7. With the brush, you will not be able to paint individual hairs very easily. Just shade the overall shape.

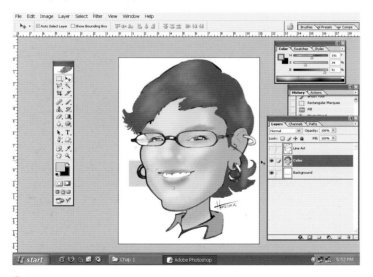

9 Paint a simple background. You may have to select and delete the white around the drawing in the Color layer. If you do not have a Background layer, click on the New Layer icon on the bottom of the Layers palette window (second from the right, next to the trash can). Rearrange the layers so the Line Art layer is on top, the Color is in the middle and the Background is on the bottom.

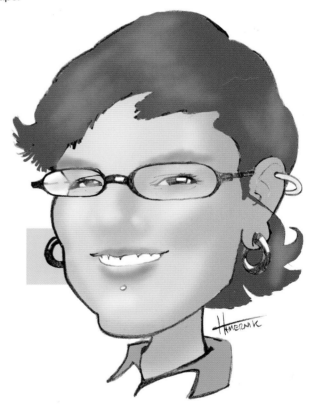

10 If you turn off the Line Art layer, your drawing should look like this. Notice how I painted right over some of the hair and lines of the face? You can do this to eliminate any unattractive white pixels next to the lines you drew.

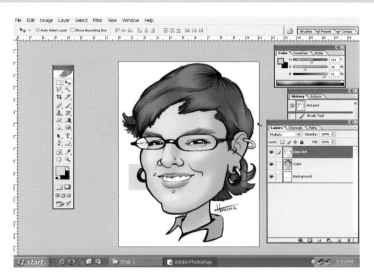

11 Turn on the Line Art layer. Be sure you colored everything you wanted to. After this next step you will not be able to make any changes. On the Layers palette window, under the red "X" close box, there is a black Options arrow; click on the arrow and select Flatten Image. This step gets rid of all the layers and leaves your image ready to print. Once you flatten, you cannot make changes to the sketch.

Computer Coloring Comments

There are many books on Photoshop®. Pick one up to learn more. As a rule of thumb for quick-sketch caricatures, computer coloring shouldn't take you longer than twice as long as you spent drawing it. If your drawing took five minutes, then spend ten minutes coloring it, on the computer or off. I recommend waiting until you are producing high-quality sketches before you start playing on the computer.

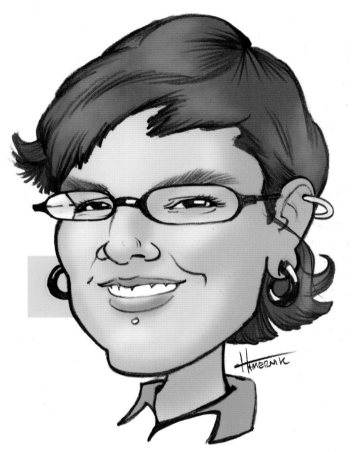

12 Your final art should look something like this. Remember, this is only an overview of the process. Photoshop ® has many variations and tools for you to experiment with. Have fun exploring and learning how to color, but don't get lost in Photoshop ®. With caricatures, the sketch itself should be the star.

Drawing Front-View Caricatures

From now through the end of the book, you will see many examples. Follow along and practice with the pattern I explain here. Using this pattern will help speed you along. By practicing and working quickly, you will progress more quickly than by obsessing over every little detail.

Basic Process

This is the basic pattern I use to draw faces. Memorize this process. Practice it by inventing faces. Draw ten faces every day for twenty days in a row. Do this before you try to sketch anyone in person. You need to know how to draw a caricature in general before you can try to make it look like someone. When you are sketching someone, you don't want to get stuck in the process. It will be hard enough getting a likeness of your subject.

Our Model

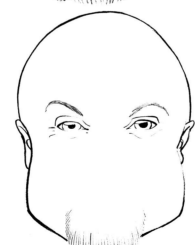

1 Begin with one cheek and work your way down to the chin. Continue up the jaw to the other cheek. Try to do this all in one stroke. In this example, I drew down to the chin on both sides and then added the goatee. Add the ears at this point, if they are visible.

2 Add the hair (or lack of). This one is easy—just draw the outline of the head.

3 Work your way down the face. Begin with the eyebrows, then add the eyes. Draw one eyebrow, then the other. Avoid drawing the eyebrow and eye on one side and then starting the other. It is much easier to mirror your strokes as you go.

4 Add the nose. Make sure you add all the details while you are on that section. Complete each section before moving on.

5 Add the mouth opening, lips, smile lines, dimples and facial hair. Keep it plain and simple. Finish one section and move onto the next. This improves your speed tremendously.

6 There should be no floating heads, so add a neck and a collar. Be sure to sign and date your work.

7 Add some color and a simple background to polish it off. Review the coloring section in chapter 1 for tips.

Know the Process

Practice by inventing ten heads a day. Focus on getting the process down: jaw, hair, eyes, nose, mouth, neck and signature. Try to do this in three minutes. Now is a good time to work on your speed.

Using an Advanced Approach

Only after you have practiced the basic approach for at least three to six months should you consider trying this advanced approach. Trust me—this is much more difficult because you have a lot more choices. Save this for later.

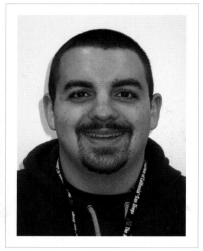

Our Model

1 Draw the eyes without drawing the face outline. You aren't contained by the outlines, so you need to plan how far apart they will be. Don't let the sketch grow too big.

2 Add the eyebrows. Draw the correct color, texture and volume. Look for how close or how far they should be from the eyes and from each other.

3 How far down should the nose go? How wide should it be? Draw the nose after you've asked yourself these questions.

4 How wide is the smile? Learn to control your exaggerations. What feature dominates the face? Focus on exaggerating that, and simplify the rest.

5 The face shape needs to fit properly with the features. The cheeks go from the eyes to the corners of the smile lines. Add the ears after you draw the outline of the face.

6 The hair is the final element you will add; it "caps" off the drawing. Sign and date your sketch.

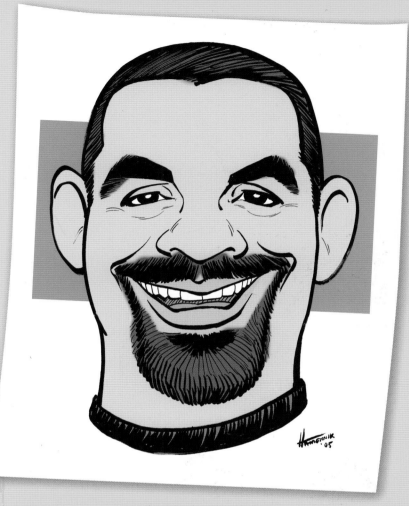

7 Add some color and a simple background.

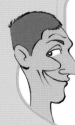

Use Your Face Shape

Artists can get lost using this approach because they are never contained by any feature. By drawing the face shape first, you are limiting yourself, which is better for now. If you miss on the face shape, you should start over. A face shape is very important in getting a likeness of the person. This is another reason why you should wait to use the advanced approach until you've mastered the basic approach.

Distance, Anchor and Pivot Points

What should you look for when drawing each feature? Here are two principles that will organize your thought process. Everyone has two eyes, but what makes one person's different from the next person's? It is the shape, angle and distance between them. I will cover shapes feature by feature later. But the anchor and pivot point principle will help you identify the angle of that feature. The distance principle will help you place the feature on the caricature.

For starters, familiarize yourself with these two principles that you need to know to start drawing.

Principle 1: Anchor and Pivot Points

Anchor points do not move, which is easy enough to remember. Pivot points move. Every feature of the face will have an anchor point and a pivot point. Anchor points are the center of the feature, and pivots are the edges of the feature. I will point them out feature by feature on the following pages.

Principle 2: Distance

How far is one side from another? How far is one shape from another? The anchor and pivot points tell you how to draw the feature, and the distance tells you how far apart to place the features from one another.

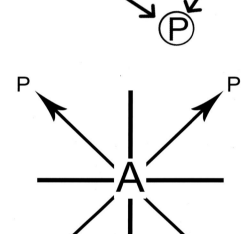

OPTIONS FOR PIVOT POINTS
Pivot points can be above, even with or below the anchor. These are the only options you will have.

ANCHOR LOCATION
Anchors will always be toward the center of any feature unless otherwise indicated.

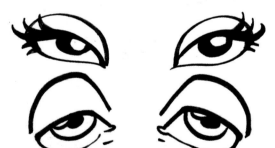

PIVOT POINTS AND EXPRESSION
Pivot points above the anchor tend to look sexy. Pivot points below the anchor tend to look tired or sad.

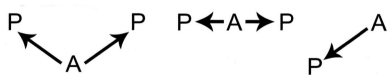

PLACING PIVOT POINTS
Find the anchor, then compare it to the pivot points. It may look subtle, but decide whether the pivots are above, even with or below the anchor.

DECIDING THE DISTANCE BETWEEN FEATURES

After you draw an eye using the anchor and pivot point principle, use the distance principle to help you place the other eye. Do the eyes look like they are close together or far apart? The distance principle is your impression of the subject's features. Avoid measuring; just go with your first impression. Remember to exaggerate. If they are close, then draw them extra close; if they are far apart, then extra far apart.

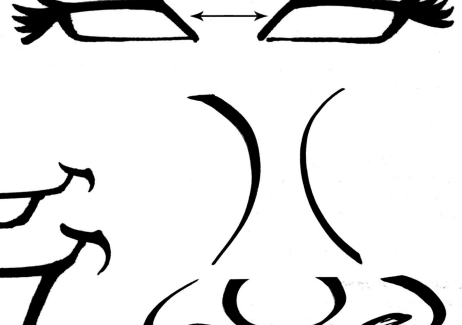

CHOOSING THE DISTANCE BETWEEN SIDES

How far should I put one side of a shape from the other? Thinking about this helps you determine what shape to draw.

DETERMINING LENGTH AND ANGLES

The distance principle tells how long to draw the shaft of the nose. The anchor and pivot points tell you what angle to draw the tip of the nose and nostrils.

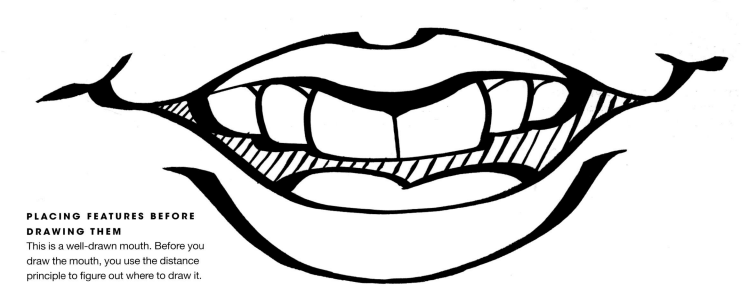

PLACING FEATURES BEFORE DRAWING THEM

This is a well-drawn mouth. Before you draw the mouth, you use the distance principle to figure out where to draw it.

Forming Face Shapes

The anchor point varies slightly from face to face. The anchor point for the whole face is the widest point of the cheek. The pivot is the corner of the jaw. The pivot will swing out, down or in.

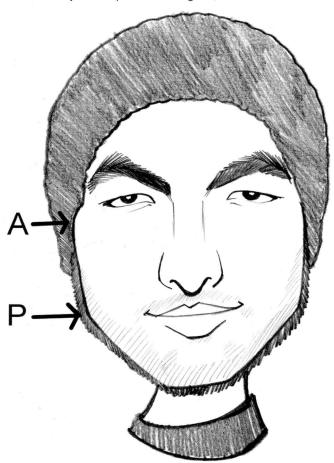

The pivot is directly below the anchor in this drawing.

START AT THE CHEEK
The face shape always begins with the cheek. Work your way down toward the chin.

WORK DOWN THE JAW
There may be times when the beard becomes the jaw line.

CONTINUE ACROSS THE CHIN AND UP AGAIN
Draw across the chin and work your way up to the other cheek.

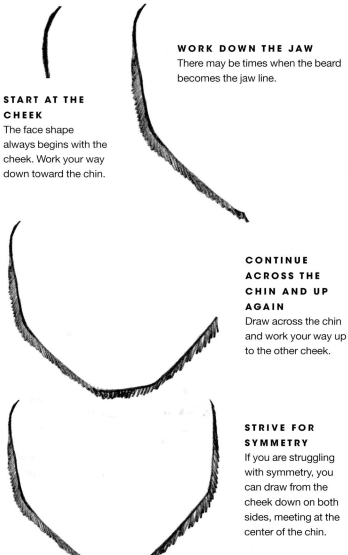

STRIVE FOR SYMMETRY
If you are struggling with symmetry, you can draw from the cheek down on both sides, meeting at the center of the chin.

FACE VARIATIONS
Draw a line going from the anchor to the pivot on each of the following faces. Which pivots out? Which is even? Which pivots in toward the chin?

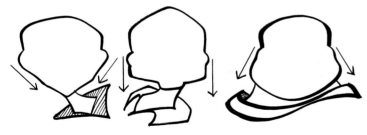

FINDING PIVOT POINTS MORE EASILY

If you struggled with finding the pivot points in the examples on page 28, try ignoring the facial features and focus on the head shapes only.

CHIN VARIATIONS

Cleft chins and double chins are very important to the face shape. Capture them accurately.

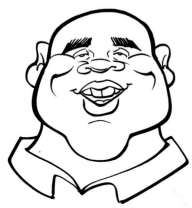

BEARDS AND OTHER FACIAL HAIR

There is not a secret formula, just a pattern to follow, when drawing facial hair. Below are a few examples of beards for this guy.

SAMPLE FACE SHAPES

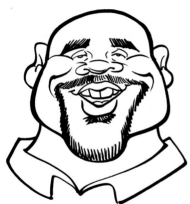

GOATEE

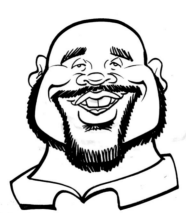

CHOPS AND GOATEE

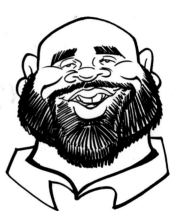

FULL BEARD

Drawing Noses

On the following pages, we will cover using anchor and pivot points for each individual facial feature, starting with noses.

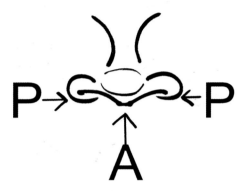

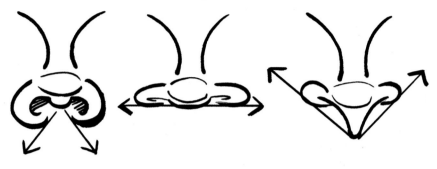

LOCATE YOUR ANCHOR AND PIVOT POINTS

The anchor point is the center of the base of the nose at the filtrum. The filtrum is the indentation of the skin directly under the nose and just above the upper lip. The pivot points are the bottoms of the nostrils. Anchors will always be at the center of the feature.

DIFFERENT PIVOT-POINT PLACEMENT

Here are examples of different pivot points. These examples may seem really cartoony. However, once you start examining real noses, you will see that this not such a huge stretch. Remember, pivots are higher than, even with or lower than the anchor point.

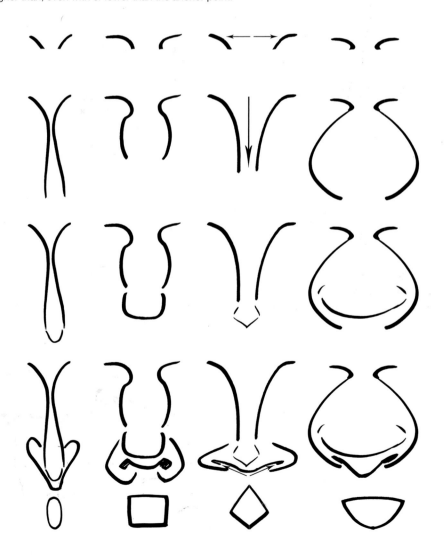

NOSE SHAPES

The shaft of the nose should be drawn as you see it. Always simplify it to a straight line or a curved line. Start at the root of the nose at the eyebrows and work your way down. Observe the ball of the nose and figure out what shape it resembles.

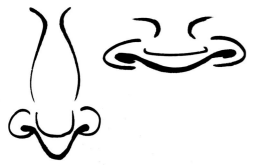

SHAPING YOUR NOSE

The length of the shaft is up to you. Is it long and skinny, short and wide or something in between?

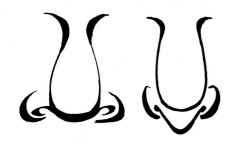

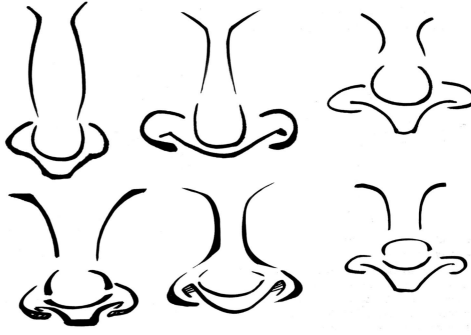

DIFFERENT NOSES, SAME NUMBER OF LINES

Here are more samples of noses for you to see how you can vary the feature while still using the same amount of lines.

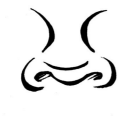

DRAW WHAT YOU SEE

Noses vary. Draw what you see. Use the same amount of lines, but vary the shapes based on what you see.

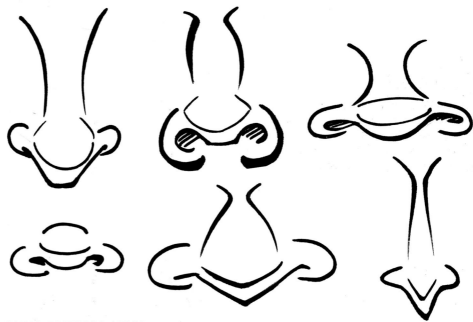

USING FAMILIAR LINES

Speed will come only by consistently using the same types of lines. Draw many different noses using these lines. Look closely for them in every nose you draw.

Forming Eyes and Eyebrows

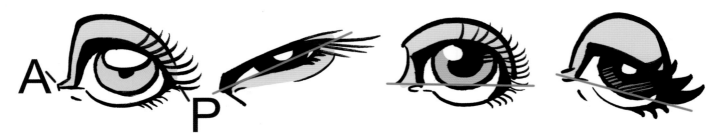

EYE ANCHOR AND PIVOT POINTS

The anchors for the eyes are the tear ducts. The pivots are where the top and lower eyelids meet on the outer edges of the eyes.

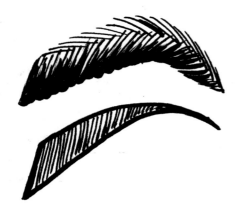

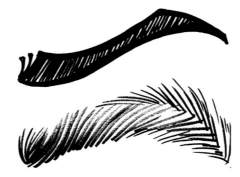

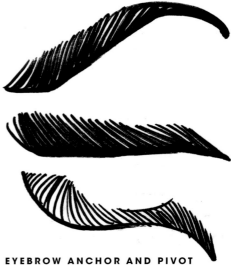

USING AN OUTLINE

Eyebrows can be neat whether you use an outline shape or not.

GROOMED VS. NATURAL

Well-groomed and natural-looking eyebrows.

EYEBROW ANCHOR AND PIVOT POINTS

The eyebrows work the same way. The anchors are by the nose, and the pivots are toward the ears. Do they pivot up, across or down?

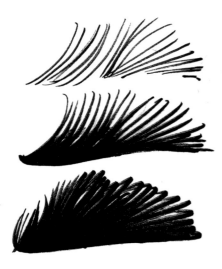

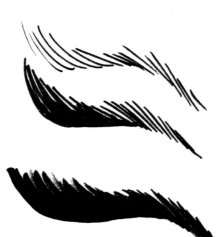

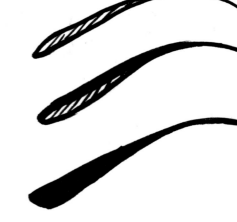

EYEBROW VARIATIONS

You can show the color and thickness of the eyebrows by the amount and spacing of your strokes. On the left are thick eyebrows, from lightest on top to darkest on the bottom. On the right are thin eyebrows, and the ones in the center are average in thickness. Look at the shape of the eyebrows, and put down fewer strokes for a thin look or lots of strokes for a thick look.

Drawing the Eyes

Try to follow this process to increase your speed when drawing eyes.

1 Begin with the eyebrows, minding the distance between them.

2 Draw the eye shape. Look at the shape first, and find the anchor and pivot points. Draw one eye and then the other.

3 Continue with the eyelids for both. Notice how we aren't bouncing back and forth? Draw one thing at a time.

4 Add the highlights, pupils and irises. (See "Eye Color Characteristics" on page 34.)

5 Finish off with eyelashes and lower eyelids, if necessary.

 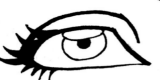 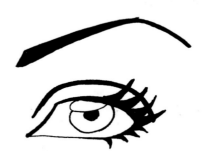

Varying the Eyes

VARY YOUR SHAPES
This example shows manly, square eyes.

ADDING LASHES
Even the most manly, square eyes will look feminine if you add eyelashes.

YOU ARE FEELING VERY SLEEPY!

SURPRISE!

THE IRIS AND EXPRESSION
How much of the iris you show has a lot to do with the expression of the eyes. Here we have "sexy."

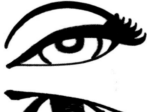

Curved lines look feminine. Angular lines look masculine.

A larger iris will make your subject look younger. Think Bambi.

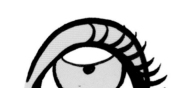

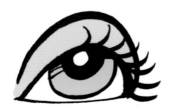

EYE COLOR CHARACTERISTICS
Each eye color should be drawn with different highlights, pupils and irises. Study this chart. Look closely at the differences among the highlights and pupil sizes. Blue eyes are drawn differently than brown eyes, etc. Practice by drawing them ten times each. This is very important when your sketches will not be in color.

SAMPLE EYES

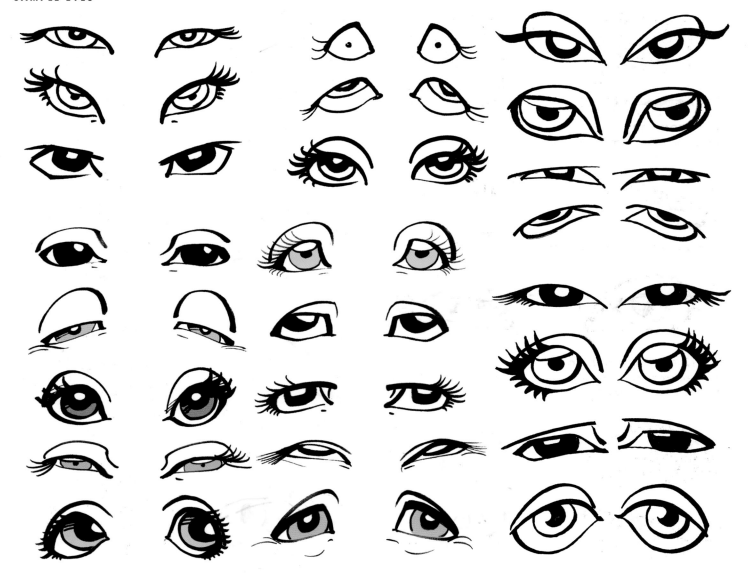

Creating Mouths

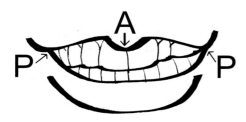

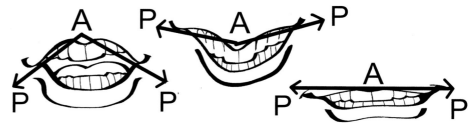

MOUTH ANCHOR AND PIVOT POINTS
For the mouth, the anchor is the dip of the upper lip. The pivots are the corners of the mouth.

VARY MOUTH SHAPES BY PLACING PIVOT POINTS
Pivot up, across or down? Is this starting to sound repetitive? You see, there is no mystery to caricatures. Just lots of repetition with a variety of shapes.

MAPPING THE MOUTH
Start the mouth at the anchor point and draw toward the pivots. Be sure to draw the correct angle (up, across or down). From the corners, draw down and meet at the middle. Be sure you capture the correct shape of the mouth opening.

ADD LIP SHAPES
AND MAYBE A MOUSTACHE
Add the upper and lower lip shapes to the mouth. Observe the shape of your subject's lips and draw them as simply as possible. Add the mustache at this point, if there is one. Be sure to get the color correct: thin strokes for light colors and thick for dark.

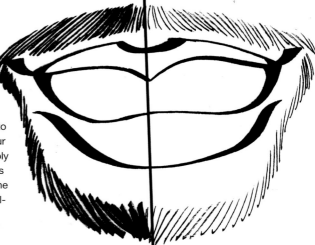

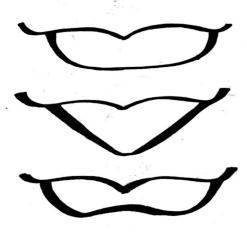

FORMING THE LOWER MOUTH SHAPE
In general, the shape created by the lower line of the mouth forms the letters "U," "V" or "W."

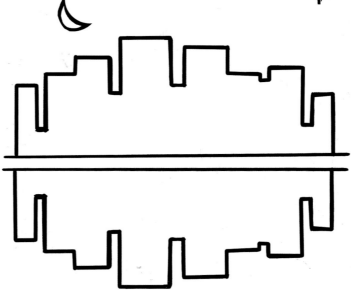

DRAWING TEETH
Think of teeth as city skylines, but upside down. Draw them as a group, not as individuals. Drawing individual teeth makes them look awkward as a whole.

A Word About Teeth

Vertical lines dividing teeth are not needed, but they should be very thin if you do decide to use them.

DRAW WHAT YOU SEE

Can you see the tongue, gaps, gums or lower teeth? Be sure your pivot points and your lower-mouth letter shape are correct.

FORMING SMILE LINES

Smile lines begin at the top of the nostrils, curve around the cheek and turn down toward the chin at the corners of the mouth.

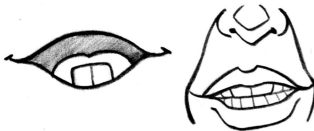

VARYING SMILE LINES

The length of the smile lines will add a lot of age to a person. On infants, use them sparingly.

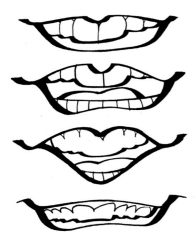

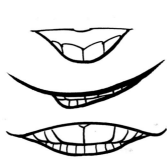

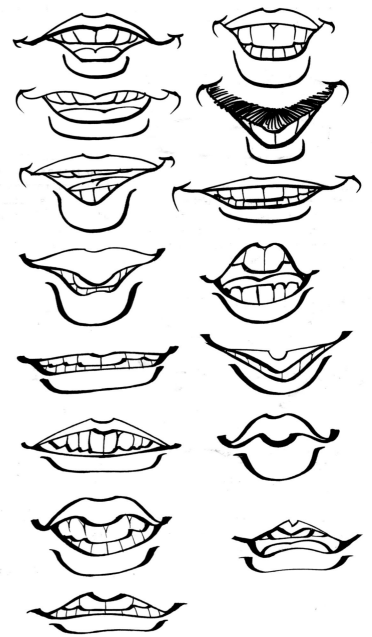

LIPS—OR LACK THEREOF

Small lips can be exaggerated by not drawing them at all.

EXAGGERATED MOUTHS

SAMPLE MOUTHS

Drawing Hair

Drawing hair is simple. You have to concentrate on only two lines.

LINES 1 AND 2

Line 1 is the hair line around the face. Line 2 is the silhouette of the hair.

EXTRA LINES

Any other lines you draw in or around the hair are purely ornamental and should be left out if your speed is too slow. These extra lines do not make the sketch look more like your subject.

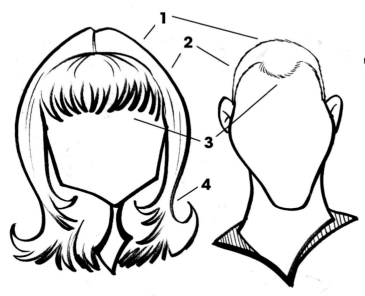

HAIR SECTIONS

Hair can be broken down into sections. Identify the top, sides, bangs or layers of the hair.

1 Top
2 Side
3 Bangs
4 Layers (mainly on females)

HAIR STYLES

Remember this: Thick lines make dark hair and thin lines make light hair. The length of the stroke relates to the length of the hair. Strokes should be drawn in the direction that the hair grows.

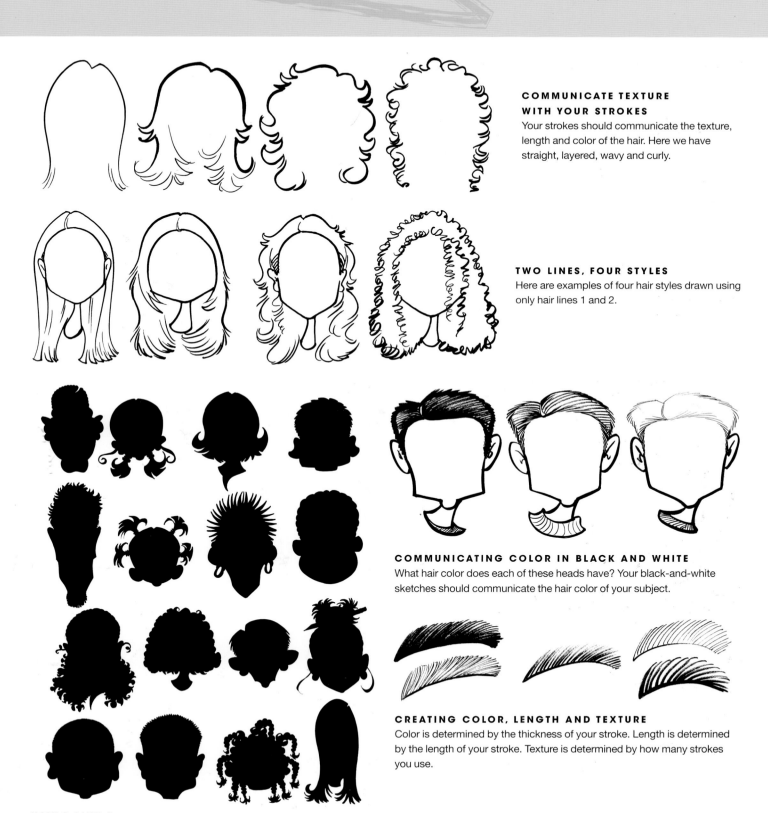

COMMUNICATE TEXTURE WITH YOUR STROKES

Your strokes should communicate the texture, length and color of the hair. Here we have straight, layered, wavy and curly.

TWO LINES, FOUR STYLES

Here are examples of four hair styles drawn using only hair lines 1 and 2.

COMMUNICATING COLOR IN BLACK AND WHITE

What hair color does each of these heads have? Your black-and-white sketches should communicate the hair color of your subject.

CREATING COLOR, LENGTH AND TEXTURE

Color is determined by the thickness of your stroke. Length is determined by the length of your stroke. Texture is determined by how many strokes you use.

USING LINE 2

Look at the difference hair line 2 makes. The silhouette of a person is made up of the face shape and hair line 2. Draw these accurately.

Embellishing Ears

START WITH SILHOUETTES
Draw the silhouette of the ear.

ADD DETAILS
Draw the details of the inside of the ear.

Aging With Ears
Placing the ears higher on the head makes a person look older.

DIVIDE THE EAR INTO THREE SECTIONS
The ear has three sections: the top, the middle and the lobe. Ears with a simple silhouette can be divided up by the inside details of the ear.

PLACING ANCHOR AND PIVOT POINTS
As in drawing the face shape, the anchor is at the top of the feature and the pivot is toward the bottom.

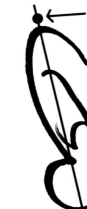

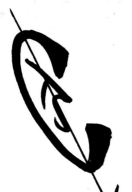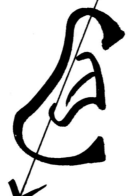

PIVOT POINT POSITIONS
Here are samples of the three pivot-point positions.

EAR VARIATIONS
Pay close attention to the silhouette. Some ears push inward at the middle, while others push outward.

SAMPLE EARS

Knowing Your Necks

The anchor and pivot points for the neck are similar to those for face shapes and ears.

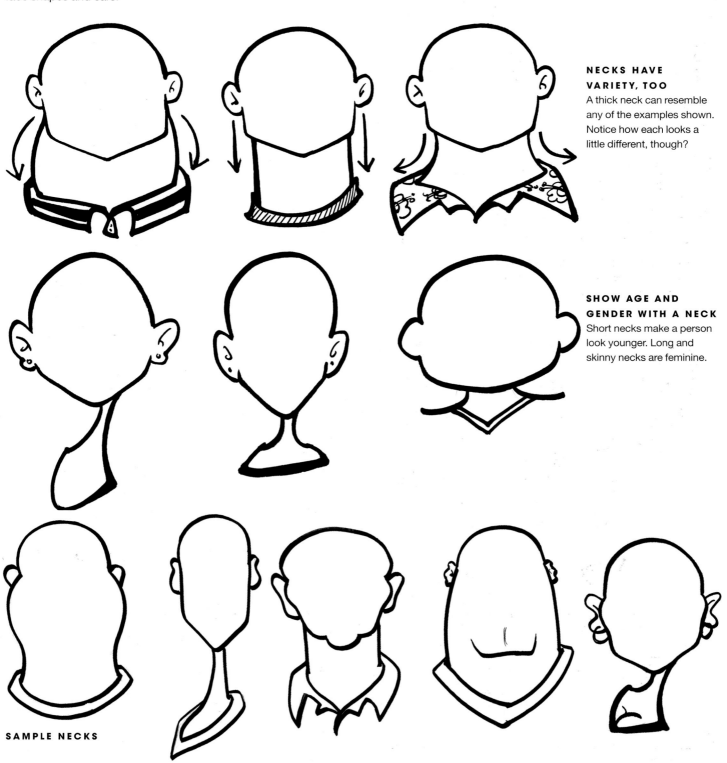

NECKS HAVE VARIETY, TOO
A thick neck can resemble any of the examples shown. Notice how each looks a little different, though?

SHOW AGE AND GENDER WITH A NECK
Short necks make a person look younger. Long and skinny necks are feminine.

SAMPLE NECKS

Using the Same Angle

Try to draw positioned from the same angle to your subject every time.

Our Model

1 Draw the cheek down to the chin and back up the other side. If you are right-handed, begin on the left, and vice versa. Add the outside edge of the ear on both sides of the face, then draw the inside of the ear.

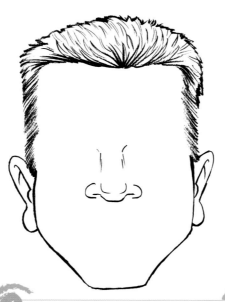

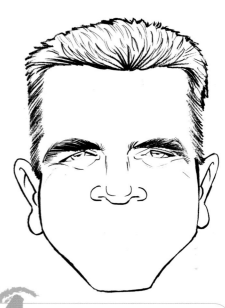

2 There are a lot of lines in the hair, but first draw the hair line around the face (line 1) and then the silhouette of the hair (line 2). (See tips on drawing hair on pages 38-39.) All the other strokes are decorative.

3 One size does not fit all. Draw the nose before the eyes if that makes more sense to you. Just try to use your same pattern as regularly as possible. Frequently switching between patterns will create problems for you. When you draw the nose, pay attention to where you drew the cheeks. The nose starts a little higher than the cheeks and ends halfway into them.

4 Now work your way down the face. Start with the eyebrows, then add the eyes. Indicate the color of the iris. Smile lines form the bags under the eyes. The difference between eye bags that make you look tired and smile lines is that you can still see eye bag lines when a person is not smiling.

5 Draw the upper mouth, based on the pivot point and anchor point. Then draw the moustache and lower lip. Add dimples and the chin crease. Using your patterns will speed you up.

6 No floating heads! Add a neck and collar, sign it and you are done with the drawing.

7 Keep the background color or design as simple as possible. You do not want to distract from the drawing.

Drawing a Baby

Our Model

When you're drawing babies, notice how the length of the cheeks is much shorter than that of the adult in the previous demonstration. Here are some other differences:

✘ Children have shorter jawlines. This creates a smaller area for the features to fit into.

✘ The features sit lower on the head.

✘ Their craniums appear larger because the features are so low on the head.

✘ As they age, the facial features move up the head.

✘ Noses on infants are small, as are mouths.

✘ The eyes and hair are great features on which to focus.

✘ Keep the ears low on the head, and the neck short and thin. Refer to head-drawing books for more details on capturing age.

1 Start with drawing the jawline. Remember to keep the length of the jaw in proportion to the subject.

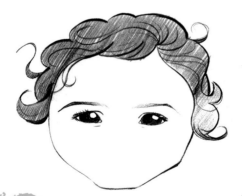

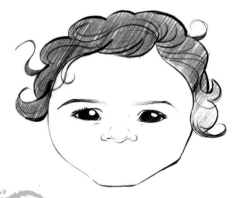

2 Describe the hair texture, color and length with each stroke. Draw line 1 of the hair, followed by line 2. Add decorative strokes after these two lines are done. You can shade in the hair area if you like. Keep it neat and organized, though. This takes time, but don't let it take too long.

3 This child's eyes are large and expressive, so draw them that way. Indicate the color of the iris by the placement and size of the highlight.

4 Draw the nose, which is usually small on children. However, the ears and nose continue to grow throughout a person's life.

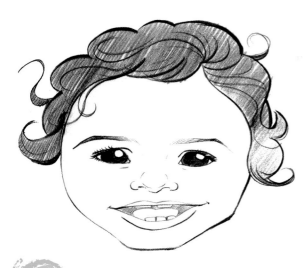

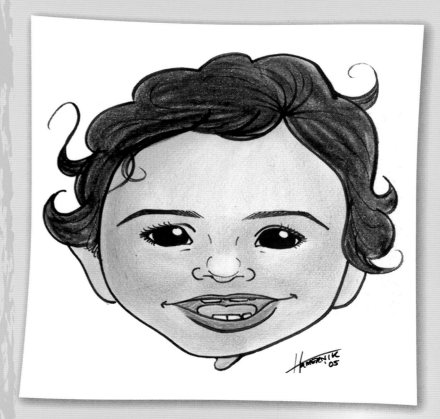

5 Watch your subjects closely from the minute they sit in front of you. The first few smiles they give you may be fake or unnatural. Ask them to smile before you begin drawing. They will begin to relax so that, when you need to draw the mouth, you will get a real smile out of them. Here, the gap and the tongue are very important details of her smile to capture.

7 Remember, color should make a good drawing look great. Coloring a bad drawing won't make it good. Practice drawing before you take up coloring.

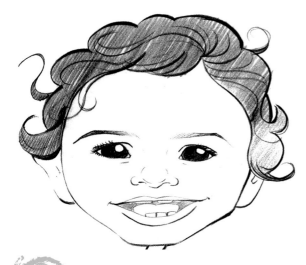

6 Necks on children are small. You will add a lot of age to a child by adding a thick or long neck. Use this knowledge to your advantage. If your drawing is looking too young, a big or long neck can add a few years to your sketch of the subject.

Shaping a Child's Face

What makes caricatures fun? Each person is different. You should have an idea of the pattern I use to draw the caricatures with by now. If something doesn't fit the pattern, don't sweat it. Adjust your pattern for that person and move on. Look at this model, for example; we lost the top of his ears. No big deal—we will just insert the lobes and move on.

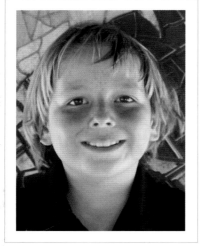

Our Model

1 Because the tops of the ears are lost, just skip them and add the earlobes. Line 1 of the hair covers up the ear.

2 Draw line 2 of the hair as a simple line. Be sure to catch the details. There are layers around the ears and at the bottom of the hair shape.

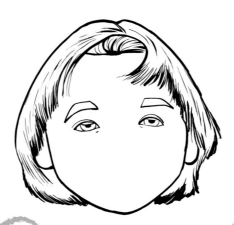

3 Draw the eyebrows as shapes, not hair strokes. Do this when you know it will be in color; then you can add the details with your color.

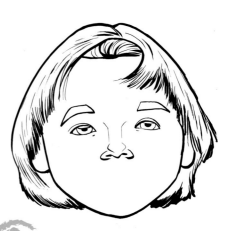

4 Notice how the "root" of the nose extends down from the eyebrows and the brow ridge and forms the inner side of the eye socket. All the parts of the face are related to each other. Even though we are playing with the proportions, the parts must still fit together.

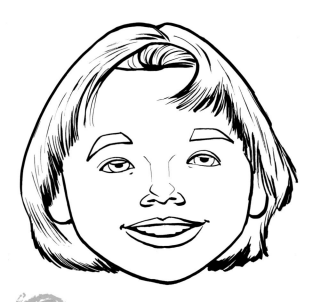

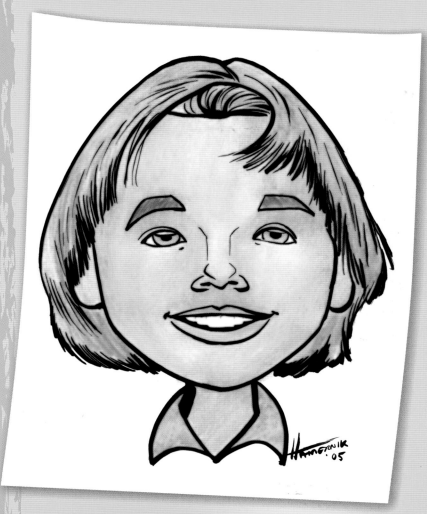

5 Place the mouth. Smile lines are another age indicator. Long smile lines add years to your subject. Keep them short on kids and even nonexistent on infants.

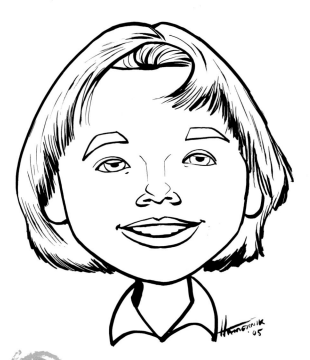

6 The neck and collar always finish the sketch. Memorize a few collars and always draw those. Drawing the exact collar you see will not make the sketch look more like your subject.

7 Once you are finished, quickly evaluate your sketch. Here I would have drawn hair line 2 a little thinner. He has blond hair, so there was no need for such a bold line.

Planning Ahead

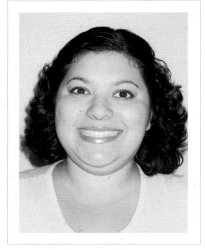

Our Model

1 The jawline is not predominant here. Draw down the neck line on one side, then the other. Connect the two lines with hair line 1.

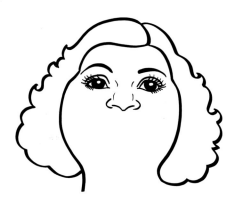

2 Draw hair line 2 to accurately describe the hair length and texture. Notice how we clearly understand the hair style. You only need the two lines.

3 Be consistent. Some sketches will be more graphic than others. When you stylize, be sure to keep the look consistent throughout the entire sketch. Draw the eyebrows and eyes to have the same look as the face and hair lines.

4 The nose only needs a few lines, so don't overcomplicate it with too many. The simpler and cleaner you draw, the better the caricature.

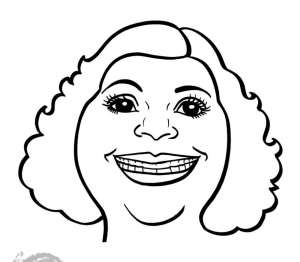

5 Add the smile and the chin. Since the jawline is not emphasized, add the chin at this point. The chin will always show up; it just may not be connected to the jawline.

6 Finish the drawing by adding a simple collar line. Style it so it fits with the look of your subject.

7 Keep your colors consistent, too. The coloring should reflect the same amount of detail as the sketch.

Practice in Person

The best way to practice is by drawing in person. Go to a local coffeeshop or café and draw there. People will come to you to see what you are drawing. Tell them you are trying to learn how to draw comic portraits, and ask them if you can practice by drawing them. Tell them it will only take a few minutes. Many times, they will be happy to get a free sketch done and may even tip you. This is an easy way to practice without pressure and maybe even make some money.

Simple Faces

There are times when the face shape does not say anything in particular to me. This means that there is probably another feature screaming for attention. If the face is simple, then draw it that way.

Our Model

Draw a simple jawline.

Hair line 1 covers the ears, so don't feel as though you have to include them. Draw what you see; leave out what you don't.

Simple shapes, such as hair line 2 here, help attract attention to other features by not attracting attention to themselves. If it is plain, then leave it that way.

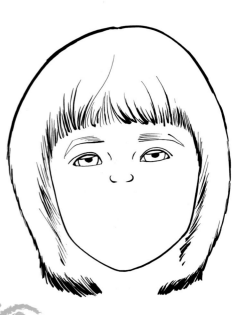

It is very important to stick to your pattern. Work your way down the face so you don't miss any details. I have seen artists leave out eyebrows, glasses and lips by accident. Skipping around the face will make you miss things.

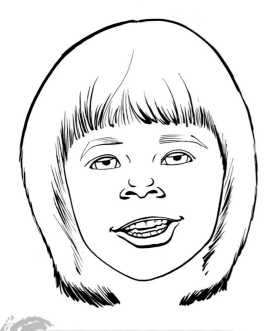

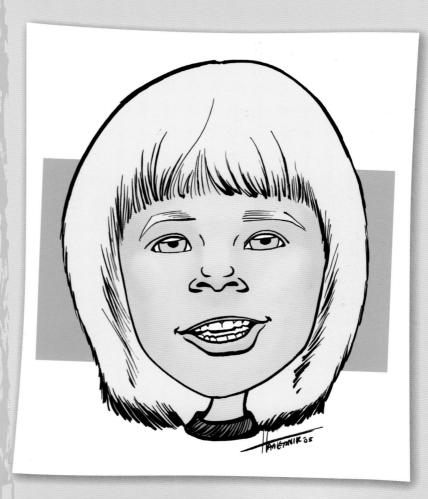

5 Finish the face by adding the nose and mouth. Is it starting to feel easier now? We are drawing the same lines over and over from face to face. They are just arranged differently for each person.

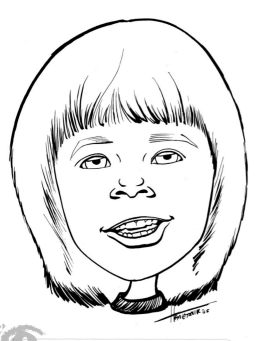

6 Add the neck, collar and your signature to complete the sketch. Pencils and markers down. Other than the background, you should not have to add anything to the drawing at this point.

7 Background colors should be muted. You want them to stay in the background and not take away from the face. You can use really any color, but, when in doubt, stick to a light baby blue.

When a Model Is Between Views

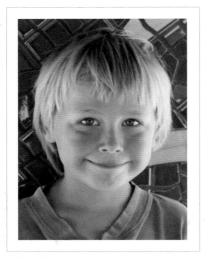

Our Model

No matter what you say to your model, sometimes he will not look right at you. Here, our model is turned ever so slightly. When the subject is between a front view and a ¾ (or slightly turned) view, it's called a *cheat*. The far side of the face changes slightly in a ¾ cheat. We see a little less of that side since it is turned away from us. As a result, lines and shapes on the far side will appear a bit closer together to each other and less wide. When the turn is this subtle, don't sweat it. After practicing the ¾-view demonstrations in chapter 3 (starting page 64), it will become a lot easier. For now, just follow along.

1 Draw the jawline, ears and hair line 1. The face is turned very slightly to our right, so the far side of the face will look just a little different—more compressed. Hair lines appear closer together, the line from the chin to the cheek looks slightly shorter, and we may not see as much (if any) of the ear on that side.

2 Here, add the hair line 2 as an easy shape. Make it slightly rounder on the near side (our left) and a bit flatter on the far side (our right).

3 Draw the eyes and eyebrows based on what you learned on pages 32–35. The shapes on the far side of the face will be slightly different. The eyebrow on our right will look a bit shorter in length, and the eye will look a bit smaller and not as wide as the eye on our left. There is also less space between the far eye and the cheek line.

4 Notice the very subtle differences in a ¾-cheat nose versus a front-view nose. Notice how the nose is placed closer to the right cheek than the left, since we see less of the right side of the face. This is in keeping with how we placed the eyes and eyebrows.

5 Thin lips can be exaggerated by not drawing them at all. Don't feel pressured to draw them.

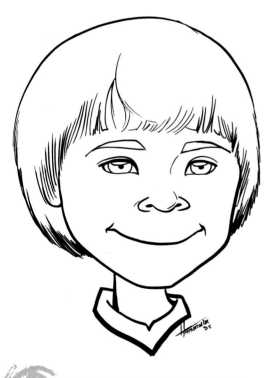

6 You can use a straight line and a curved line for the neck to create variety. The curved line leads the viewer into the face, so place it on the side the subject is facing.

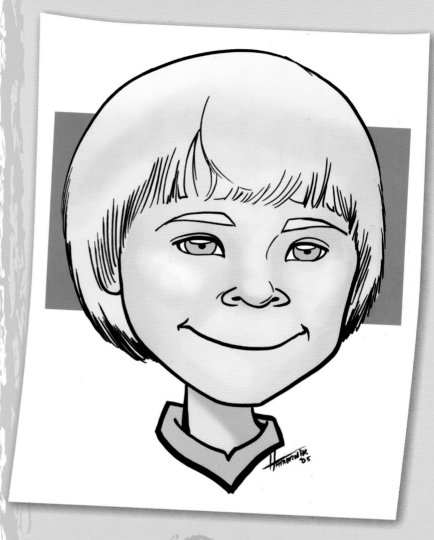

7 Add color and a background to the sketch. Make sure you are happy with the quality of your drawings before you go out and buy pencils for coloring. I have seen artists who spend a lot of time coloring poor sketches. When they are done, they never feel any better about the sketch even though they put all that time into coloring it.

Evergreen Gift

Caricatures make great gifts. A nice face sketch in color will run $15 to $40 from a street artist or theme park artist. A commissioned caricature will cost $100 or more. Place your drawing in a nice frame and it will be well received.

Working With Ponytails

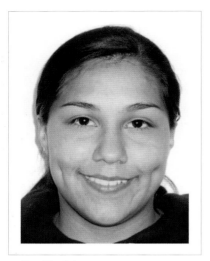

Our Model

Caricatures are cartoons. Cartoons are exaggerations of life. This means we can change reality so that we can get our point across. Ponytails, in general, cannot be seen from a front view. Ask your subject to turn around or pull her hair over her shoulder. This way you can see how long the hair is and add it over the shoulder. If the ponytail is really short, draw the subject's neck at an angle so you extend the hair just past the jawline and still see the short ponytail.

1 In general, the best point to start a sketch over is after you've drawn the jawline. If you are not happy with the sketch at this point, you probably will not be happy with it in the end.

2 Draw the ears and hair lines; then fill in the hair as you see it in the photo. Ponytail styles will look like men's short hairstyles if you don't show length.

3 Well-groomed eyebrows are important to getting this likeness. Draw them neat, and catch the correct angle for the pivot point. Draw the correct iris color. Even notice the direction that the eyelashes grow. Simplifying the face doesn't mean changing what you see.

4 When drawing women, you can downplay the size of the nose by not drawing the shaft or by using thin lines. Doing this will attract less attention to their noses, and they will thank you for it!

5 Look for subtle quirks in your subjects. Can you see the slight tilt in her smile? Enhance those types of details. Look for dimples. Because not everyone has them, dimples are important in getting a likeness.

6 Here I've drawn the subject's long hair over one shoulder and angled her neck slightly.

7 The highlights on the top of her head and in her ponytail give dimension and indicate shine.

The Stare-Down

Do you enjoy being stared at? Most people don't. There will be times when your subject sits down and suddenly realizes that you and everyone nearby is staring at him. This can trigger a stare-down between you and the subject. Try telling a joke to loosen him up. Try a few times, but if he is not cracking, it's best just to draw as fast as you can. The only way he is going to relax is when he is out of your chair. Avoid making yourself uncomfortable and just get it done quickly.

Our Model

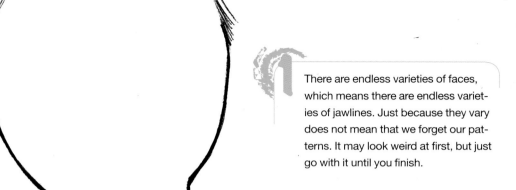

1 There are endless varieties of faces, which means there are endless varieties of jawlines. Just because they vary does not mean that we forget our patterns. It may look weird at first, but just go with it until you finish.

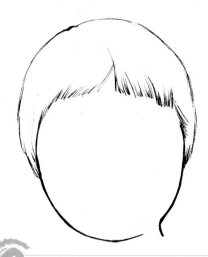

2 This is a standard haircut for kids, particularly boys. I can draw this hairstyle with my eyes closed.

3 The nose breaks up the face. Because the model's cheek lines are nondescript, use the nose to help place the other features.

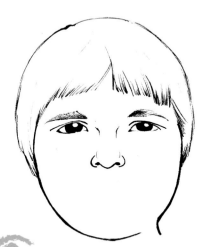

4 Now work your way from top to bottom. The eyes may not always come out exactly symmetrical. Don't worry; this isn't unusual with caricatures that only take a few minutes to draw. There always will be some mistakes in it. A good caricaturist captures a likeness and gradually makes fewer mistakes.

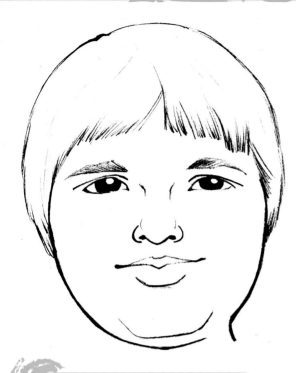

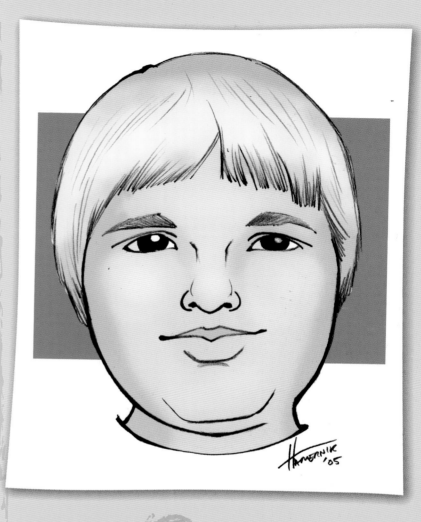

5 Don't spend too much time trying to coax a smile out of an uncomfortable subject. Just finish and move on to the final touches.

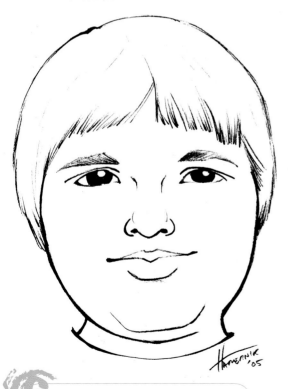

6 Once the collar is added, the original jawline makes sense. Think all the way through your drawing from the very beginning.

7 Coloring the sketch shouldn't take you more than one to two minutes.

Knock, Knock...

Learn some jokes. Some people really don't know how to smile. You have to try your best to make your subject relax. Remember, most people don't like being stared at. If they won't smile, try a joke or two. Sometimes, even the best of us can't break a good poker face like this one.

Hair With Texture

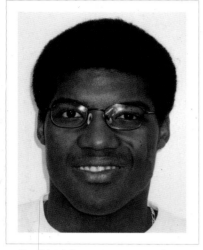

Our Model

Hair can be difficult at times. Here, the hair creates an oval shape around the head. The hard part is drawing curl shapes around the hair lines while maintaining the overall oval shape. To avoid ending up with a lumpy, bed-head shape, use a really dry marker or a hard pencil to draw hair lines 1 and 2, establishing the head shape and the line where the hair meets the face. Keep the lines as thin and light as possible. Now you have a guide as you add the curls over these lines. You shouldn't see the original shape lines when you're done.

1 Start with the jawline and hair line 1. After lightly placing the hair line with a dry marker or a hard pencil, switch back to your regular marker or soft pencil and add strokes describing the hair texture and length directly over the guideline.

2 Lightly add the hair line 2, then add the curls as you did with hair line 1 in step 1. Then add the ears. When drawing a specific head shape (such as a circle), always draw a thin, light line of the shape first. Then draw the hair strokes over it. This will help avoid lopsided head shapes.

3 Draw every aspect of the face as you see it. Add eyeglasses while you are drawing the eyes. Ask yourself what size and shape they are. Asking yourself questions will keep you focused on what you are trying to draw.

4 Add the nose. Make sure its placement and its bridge shape make sense in relation to the eyeglasses you drew. Otherwise the glasses will look like they're floating on your subject's face instead of being supported by the nose.

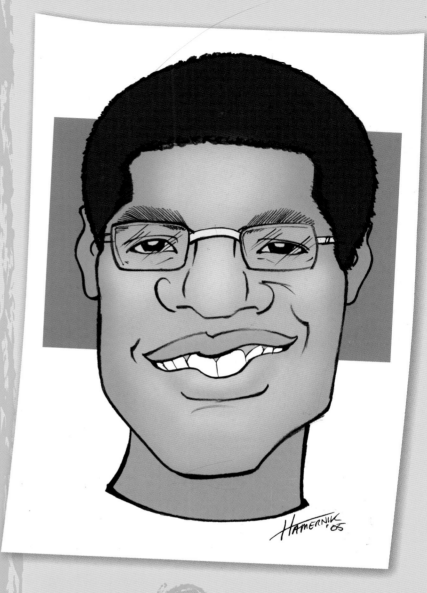

5 If your model smiles, draw the smile. If he is laughing, draw him smiling still. When you laugh, the shapes of the cheeks, eyes, eyebrows and mouth change. At this point of the drawing, our model was not laughing. A laughing mouth does not fit in here. Your subject has to be laughing when they first sit down, so you can draw all the features as they look when laughing.

6 Thick necks are masculine and add age. Think about the neck before you draw it. Long, thinner necks work better for women.

7 Refer back to the coloring advice on page 13 for tips on skin tones, eye color and hair color.

Embellishing Features

The nose and jawline are generally masculine features. Feel free to enhance these on men. The eyes and lips are good features to exaggerate on women.

Working With a Beard

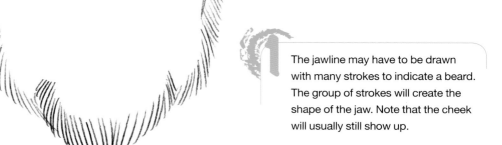

A beard creates the jawline, and making it look symmetrical can be tough. Use a light line to establish the shape you are about to draw, then add the individual strokes for the hair. You can also just draw half of the beard and stop. Draw small dots on the other half, where the rest of the beard will be. Think of it like connect-the-dots drawings. Use these dots to help you finish the beard symmetrically.

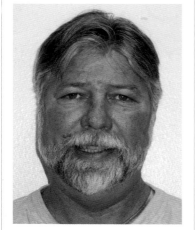

Our Model

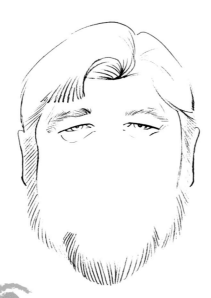

1 The jawline may have to be drawn with many strokes to indicate a beard. The group of strokes will create the shape of the jaw. Note that the cheek will usually still show up.

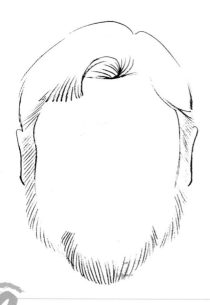

2 Don't completely finish the beard yet. We need to place the facial features first. Continue with the pattern by adding the ears and hair lines 1 and 2.

3 Work your way from top to bottom. In general, the older your subject is, the more lines you can use on a sketch.

4 Now that all the facial features are in place, go back to the beard.

5 Fill in the space with the hair strokes of the beard. Organize them into sections, minding the direction of the hair growth in each.

6 Complete the sketch by adding the neck, collar and your signature.

7 As you color, use the white of the paper when needed. If you want to create a highlight area, leave that spot without color, or add a much lighter layer of color there. Avoid using white colored pencils to try to create highlights in areas you've already colored; they do not cover up other colors.

Exercises to Improve Your Skills

In between drawing entire faces, take breaks and try these short, fun exercises to polish up your caricature drawing skills. If you've been working in pencil, now's the time to try getting comfortable with your markers.

MIRROR, MIRROR
Practice drawing mirror images of each type of stroke. Better to practice than to mess up on a live sketch.

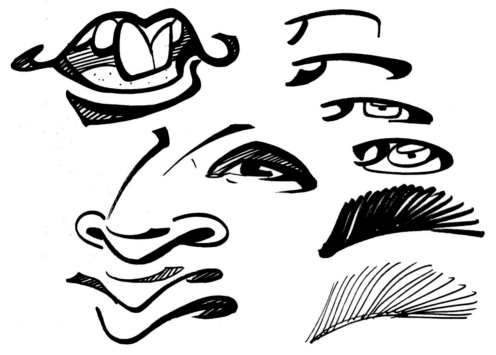

MIRROR IMAGES IN HAIR
You will often use mirror strokes in hair shapes.

CYOF—CREATE YOUR OWN FEATURES
By inventing features, your confidence will increase tremendously. Practice making them as funny as possible. This helps you envision exaggerations when drawing a live person.

PRACTICE, PRACTICE, PRACTICE!
This is a sample of some practicing I did. It doesn't matter what you draw. Draw all over the page, just as kids do when they doodle. Fill the page and throw it away. You can easily fill a page in one or two minutes. Practicing fifteen minutes every day for two months will get you through five hundred sheets. After that many pages, you will have a good handle on using markers.

BECOME A MAD IMAGE SCIENTIST
By inventing different looks, you can capitalize on them when you do couple sketches.

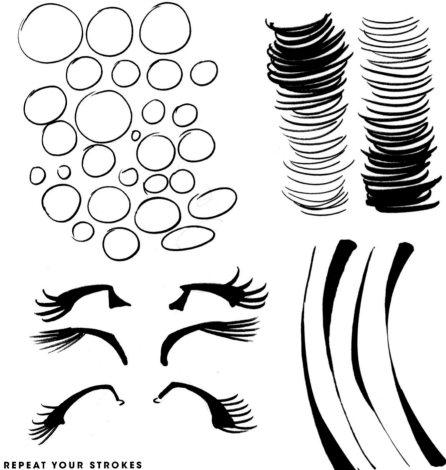

VARY YOUR LINE PATTERNS
Adding a little variety in your line patterns creates visual interest.

REPEAT YOUR STROKES
Practice similar strokes by repeating them over and over.

DON'T BE TOO SKETCHY
Every line you draw falls into one of the three "I-C-S" categories: "I" (straight lines), "C" (curves) or "S" (snaking curves). Thinking like this will prevent you from drawing lines that are too sketchy.

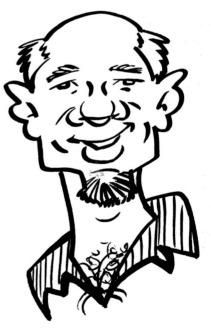

DRAW SOME MINI-HEADS
Make up small heads to practice dexterity.

Drawing ¾-View Caricatures

Basic Process

As with the front-view caricatures, draw in the same pattern or order for every sketch, with few exceptions. First, have your model look right at you. Then tell her to turn her head until you can only see one nostril, giving you a ¾-view of the face. Make sure her head is not tilted. Avoid skipping around the face when you're drawing the features; you may forget to draw an eyebrow or something else.

Our Model

Every now and then, draw from your imagination. It'll sharpen your perspective... and your skills.

1 Start at the eyebrow and work your way down the face. Go around the chin and up the jawline to the ear. Be sure to line up the corners of the jaws.

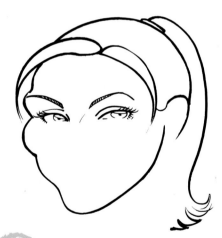

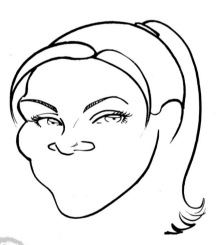

2 Next add line 1 of the hair, followed by line 2. Also add the ear at this point. Pay close attention to the silhouette shape of the hair.

3 For the features, begin with the eyebrows and work your way down the face. We will cover the differences in the eyes in a ¾ view on page 66. Approach it the same way you did in the front-view section. Flip back to page 52, where the eyes were done similarly—only this turn is a full ¾, not a ¾ cheat.

4 Add the nose. Focus on the far side of the shaft of the nose. This line will be very evident from a ¾ view. Think about the distance down to the base. Use the anchor and pivot points to draw the base.

5 Draw the mouth, making sure the corners of it point toward the cheeks. We'll see more of the side closest to us, so the far side of the mouth should be drawn shorter.

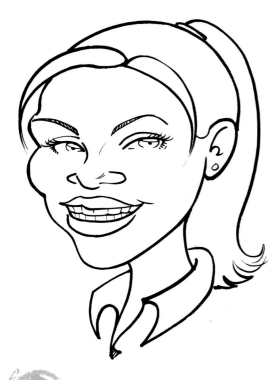

6 Add the neck and collar.

7 You can always add some decorative strokes in the hair or any other details. Do this only if you have time to. Remember that the models may be getting tired of being stared at.

Choosing Sides

If you are right-handed, start with the cheek on the left side of the face. If you are left-handed, then do the opposite.

Drawing ¾-View Eyes

To further illustrate drawing ¾-view caricatures, this section will cover the different methods for each feature as compared to the front view. We'll start with the eyes.

USING HIGHLIGHTS
You can use the highlight in the iris to direct the gaze of the eyes. This helps if you want the eyes to look in a certain direction.

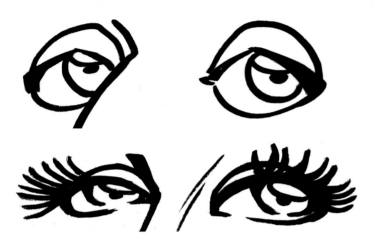

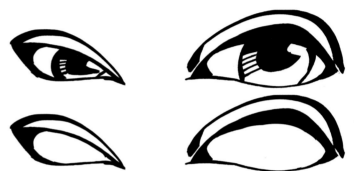

DEFINING THE EYES
Use anchor and pivot points to establish the tilt of the eyes. Go back to page 32 and review them if you need to. Eyelashes make the eyes look feminine, so skip them on men.

EYE BASICS
The eye farthest away from you will look smaller than the one nearest to you. Draw the far eye first. Think about where the nose falls so you don't draw the eye too big. Use the white part of the eye to help establish the overall shape. Always look for the shape of the whole eye first. You will draw the closer eye similar to a front-view eye.

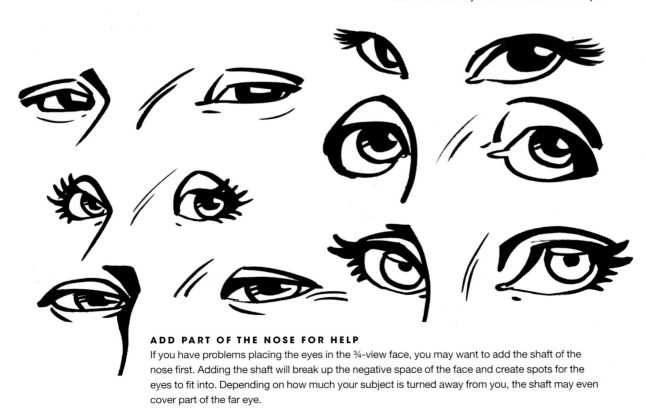

ADD PART OF THE NOSE FOR HELP
If you have problems placing the eyes in the ¾-view face, you may want to add the shaft of the nose first. Adding the shaft will break up the negative space of the face and create spots for the eyes to fit into. Depending on how much your subject is turned away from you, the shaft may even cover part of the far eye.

Creating a ¾-View Nose

When you position your subject for a ¾-view caricature, use the nose to measure the turn. Have the model turn until you can see only one nostril. Otherwise, make a mental note of how much the subject is turned based on how much of the far nostril you can see. Your subject will probably move around as you sketch and you will have to reposition them.

NOSE PROGRESSION
Draw the shaft of the nose. Decide how long it will be. Fit it properly onto the face shape you created earlier in the drawing. You can draw the base of the nose by considering the anchor and pivot points. Finish by adding some decorative strokes to better define the near side of the nose.

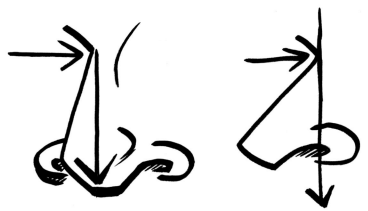

LINE UP YOUR FEATURES
Pay attention to the point where the nose shaft meets the eyebrow. Compare that to the center of the nose at the base. They should roughly line up, as in the example on the left. If the top is too far over, the bottom of the nose will look more like a profile nose than a ¾-view nose.

DEFINING THE NOSE
The far side of the shaft will define that person's nose. You can use a bold line here. Be sure that the nostrils relate to each other. The example on the right has a line that connects the two together. Do this mentally before you draw the second nostril.

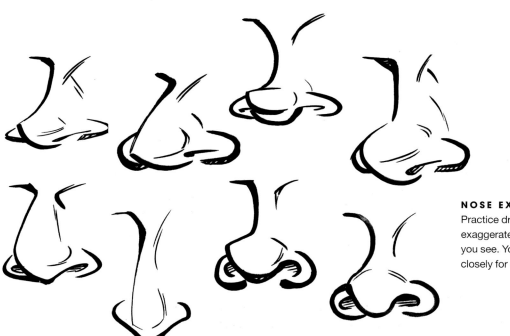

NOSE EXAMPLES
Practice drawing many, many noses. The ones here are exaggerated. Study these and compare them to people you see. You may not see these shapes at first. Look closely for subtle differences, then exaggerate them.

Forming a ¾-View Mouth

All the principles of the front-view mouth also apply to the ¾-view mouth. The big difference is that the far side is shorter than the near side.

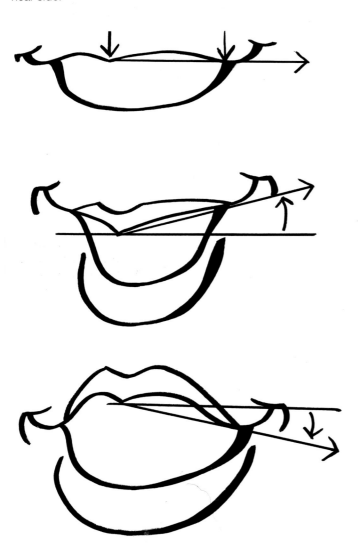

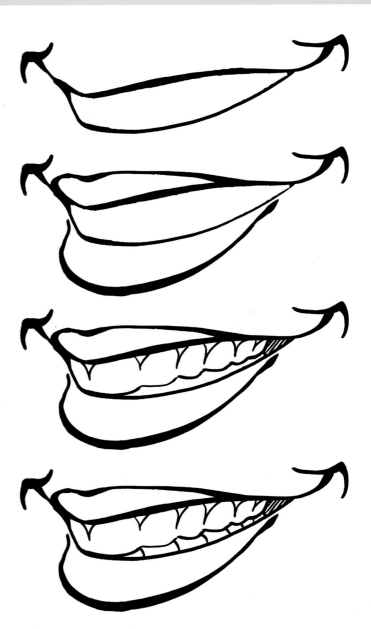

STUDY ANCHOR AND PIVOT POINTS

Look for the anchor and pivot points first, then determine whether the shape of the lower part of the mouth will form a "U," "V" or "W." The lips come after this. (See page 36 for a refresher.)

KEEP USING YOUR PATTERN

Draw the mouth using the same pattern as you used for the front view. Start with the mouth opening. Add the lips, followed by the upper teeth and then the gum line. Finish with the lower teeth or tongue, if you can see them.

Designing ¾-View Face Shapes

Face shapes will vary dramatically in the ¾ view. Study the examples on this page closely to find some of the differences. It can be difficult to make all the features line up on a ¾-view face. The only way to get good at this is to practice inventing faces. You can fit a dozen or so on a page. When you are practicing, focus on only one thing at a time. For example, draw a whole page of face shapes, then a whole page of noses. Drawing only one face shape here or a nose there will not benefit you.

AN ANGULAR FACE
This male face has many angular points.

A CURVY FACE
This female face is made up of curves and flowing lines.

A ROUND FACE
Notice the round jawline. The face shape is just as important as the features. Use bold lines to attract attention to important features.

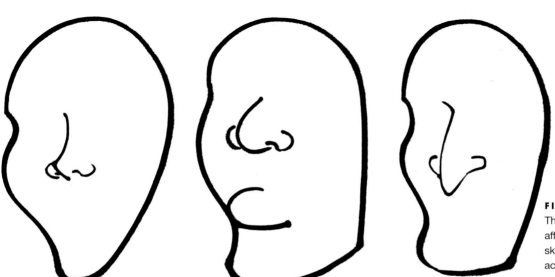

FIND THE ACTIVE LINES
The far side of the face really affects the look of the ¾-view sketch. It also contains a lot more active lines than the near side.

69

Drawing ¾-View Hair

Here is the basic process for drawing the hair in a ¾-view caricature. The only difference from the front view is in the way the silhouette shape is drawn.

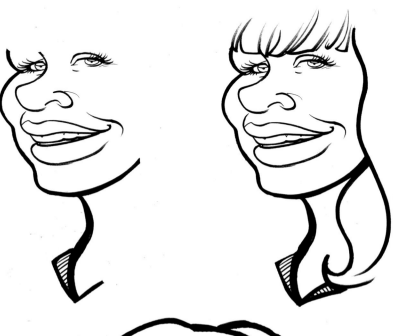

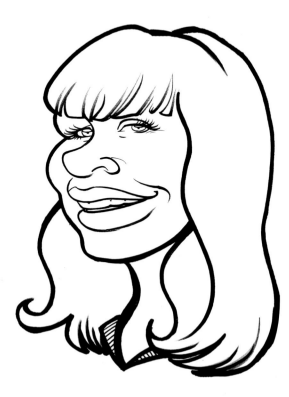

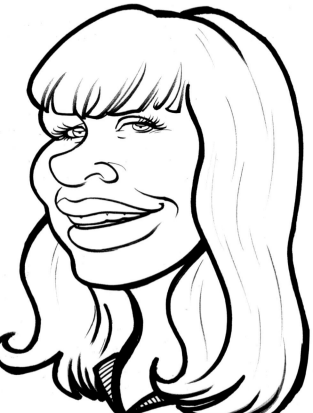

ADDING HAIR
Draw the face shape first (top left). I added all the facial features to this sketch so that we can see where the hair goes in relation to the face. Start with the hair around the forehead and work your way toward the near ear (top right). Now add the silhouette shape of the hair starting at the top of the head and working toward the near side of the face (bottom left). Add the silhouette of the far side, if necessary. Finish by accenting the hair with decorative strokes (bottom right).

Using Facial Rhythm Lines

Rhythm lines create shapes that give character to the ¾-view caricature and the profile caricature. The shape created is where you will capture the likeness of your subject. The features are still important, but the negative shape and silhouette that are created really stand out. Pay close attention to this page. It contains a great secret for creating awesome caricatures.

LOCATE THE 3/4 LINE

Draw the face shape. The ¾-view rhythm line is made up of the far eyebrow, the shaft of the nose, the far shape of the upper lip, the far side of the mouth opening and the lower lip. It's not really a "line," but an abstract concept for capturing a likeness.

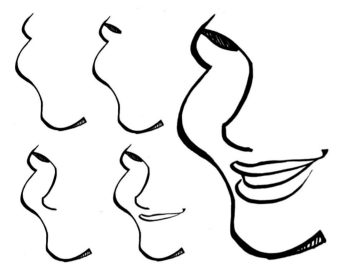

DIRECT YOUR STROKES

Here is an example of the direction each of the strokes should follow. Pay close attention to where the rhythm line meets the face silhouette.

LOCATE THE PROFILE LINE

The profile rhythm line is made up of the eyebrow, the top of the cheekbone, the silhouette shape of the cheek, and the smile line going to the corner of the mouth, finishing at the chin crease.

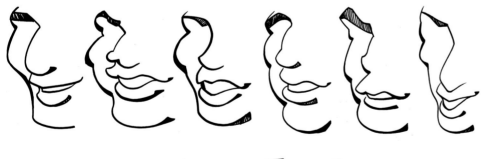

NOTICE DIFFERENT CHARACTERISTICS

Study these examples. Look at the difference in character types that are created by the face silhouette and the rhythm line. Note that sometimes the far smile line will be predominant.

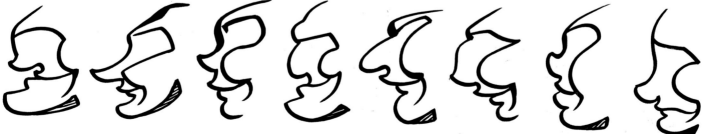

CREATE UNIQUE CHARACTERS WITH RHYTHM AND PROFILE LINES

Study these profile samples. Look at the character type created by the profile line and the rhythm line.

Pulling the Face Together

Just like when you draw caricatures from the front, follow the formula without changing it. Draw in the same order every sketch. Have your model look right at you, then have her turn her head until you can see only one nostril. Be sure the head is not tilted.

Our Model

1 Draw the profile line of the face. Begin at the eyebrow, then draw the cheek, jaw and chin. Vary the line width for interest. Thicker lines attract attention.

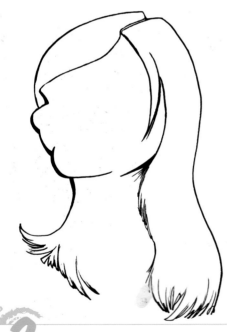

2 Add the hair line around the face. Then add the silhouette shape of the hair. Use a "V" shape to indicate a part in the hair—the deeper the "V," the puffier the hair will appear. You can break the two lines up by using decorative strokes, but they should appear to create a "shape" of hair.

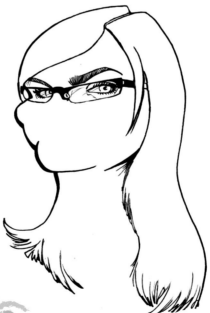

3 Draw the eyes. These are the windows to the soul. Draw them carefully; if you miss the mark here, you are heading into troubled water. Draw the far eyebrow first, then the near one. Continue with the far eye, then the near one. Add the glasses now if you wish.

4 Draw the nose. Start at the bridge by the eyebrow and work your way down to the tip of the nose. Add the near nostril, then the far one if you can see it. Add any decorative strokes that will help define the nose.

5 Draw the mouth area. There is no opening in this model's expressive grin, so you will simply draw the top lip, then the bottom one. Don't forget the smile lines.

6 Complete the sketch by first drawing the neck and collar. Go to the top of the sketch and work your way down adding decorative strokes. Look for anything you may have skipped: freckles, earrings, strokes in the hair, glasses, and so on.

7 Color your sketch. See pages 12-13 and 16-17 for tips on coloring with colored pencils.

Gender Differences

Stylize your sketches of women. Highly exaggerate your sketches of men. They'll love it. Reverse this, however, and the reactions you get won't be so positive!

Capturing a Likeness

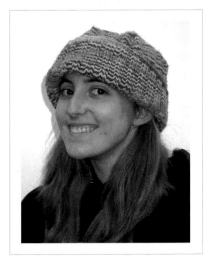

Our Model

1 Draw the profile line. What point extends the farthest? The brow, cheek, jaw or chin? Draw this all in one stroke. When you are practicing, draw the same profile line ten times in a row or until you get the exact line you wanted.

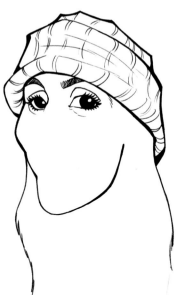

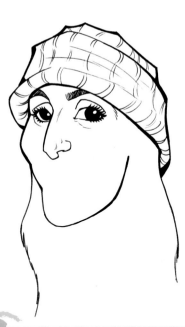

2 Draw the hair. The hair around the face is hidden by the beanie, in this case. Add the silhouette shape next. You can add decorative strokes if it keeps your flow going.

3 When you reach the eye region, draw the eyebrows first (the far side, then the near side). Then draw the far eye and the near eye. Revisit page 66 for tips on drawing ¾-view eyes. Add lashes on women only.

4 Draw the nose next, using the formula of bridge down to the tip. Watch those angles. Add nostrils, near then far (if you can see it). Don't forget any decorative strokes.

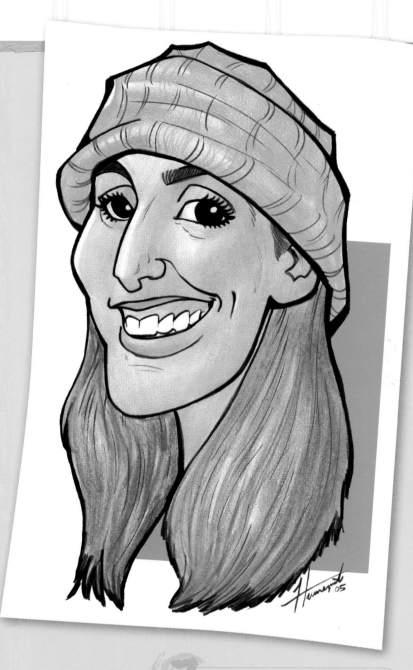

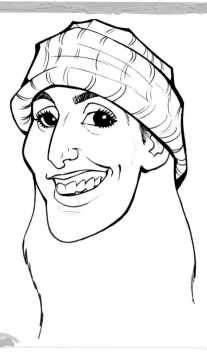

5 Draw the mouth opening first. Then draw the top lip, bottom lip, upper teeth and gums, lower teeth and tongue. Only draw what you can see. Add smile lines and dimples, plus the ear.

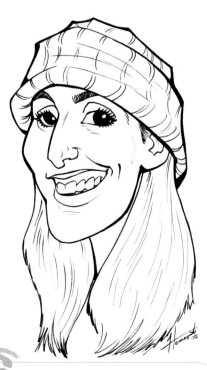

6 Finish your sketch by adding the neck and finishing the hair. Notice here that the neck is implied by the space left for it between the two sections of hair, instead of being clearly drawn.

7 When using this quick style of drawing, don't spend more time coloring the caricature than it took to draw it. Use a simple, limited palette of colors.

Vary the Profile Line

Practice varying widths of the profile line. Start the profile line at the widest point of the eyebrow ridge. Imagine a plumb line dropping straight down from that point. Ask yourself, how far does the ridge go in? How far does the cheek go out? When do you cross the plumb line again? At the cheek? At the jaw? At the chin? Remember to exaggerate.

Exactly the Wrong Pose

When your model can't seem to hold his head the way you want him to, don't stress over it. The formula will still work. Figure out how tilted the head is, and then draw all the features following the same slant. Look at the angle of the highest point of the brow ridge from one side to the other. The eyes, nose, mouth and chin will have the same tilt.

Our Model

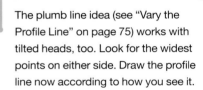

1 The plumb line idea (see "Vary the Profile Line" on page 75) works with tilted heads, too. Look for the widest points on either side. Draw the profile line now according to how you see it.

2 Draw the hair line around the face using many strokes. The strokes go in the direction that the hair is combed. Make each stroke as long as the hair itself. Then draw the silhouette hair line. Don't make it look messy. The strokes create the skull shape, and the lengths correspond to one another.

3 Start at the eyebrows and work your way down—far side first, then near side. Draw the correct indication for the eye color. (See "Eye Color Characteristics" on page 34.) You can show what color the eyebrows are by using thin lines for light color and thick lines for dark color.

4 Get all the lumps and bumps on the nose correct. Don't get lazy and start drawing the same nose shape on everyone. Use thin lines if you don't want to attract attention to the nose.

5 Draw the mouth opening, the lips, then the teeth and gums. Sticking to the formula will ensure that you don't skip over any details. See page 36 for tips on the slopes of mouths based on the anchor and pivot points.

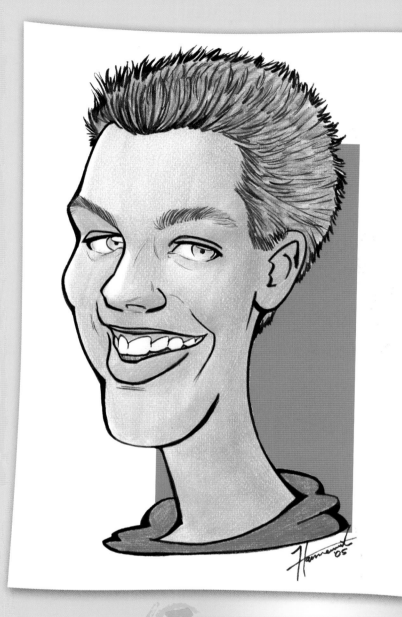

6 Draw the neck and collar. As you complete drawings, don't add so many decorative strokes that you double your drawing time. These should be simple and for decoration only.

7 Make the background shape and design simple. Limit it to one color. While you are learning, keep everything as simple as possible.

A Perfect Jawline With Facial Hair

It will be necessary to draw the profile line with hair strokes when your models have facial hair, unless you want to draw a very light guideline first. Don't worry; just draw the line you imagined, using hair-type strokes. Keep the inside edge of each stroke uniform so together they visually look like a line.

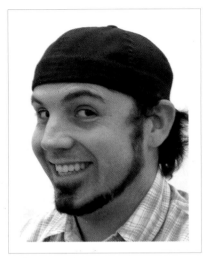

Our Model

1 You can start at the eyebrows with hair strokes and transition into the standard profile line. At the chin, draw it like hair once again. Remember to make the lines similar to the length of the facial hair.

2 The backward baseball hat replaces the hair lines. Draw the line around the face. Exaggerate the eyebrows, and make the line of the nearest eyebrow part of the hat line. Add the silhouette shape of the hat.

3 You may find it easier to draw the nose before the eyes in this case. I'll let you, as long as you promise to draw the nose first on every sketch. By now you should be comfortable with the formula, and it's OK to create your own version of it.

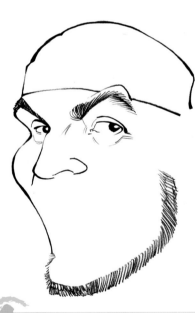

4 Add the eye area. Be careful not to use too thick a line in the lower eyelid or it will look like you're drawing an eye bag.

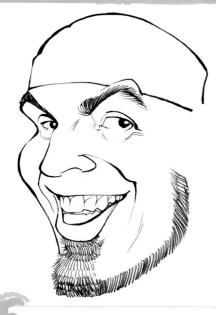

5 Add the mouth, lips and teeth. Draw the lower teeth as a group instead of individual teeth. Most people do not show a lot of their lower teeth when they smile, so you can get away with this simplification.

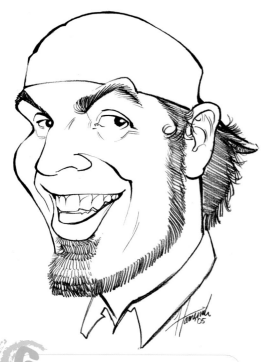

6 Wrapping up this sketch means finishing the beard, adding the hair and the bill on the hat, and drawing the neck and collar. What should you draw first? Try the neck and collar. Make sure the neck goes with the head. In this case, a thick neck is appropriate.

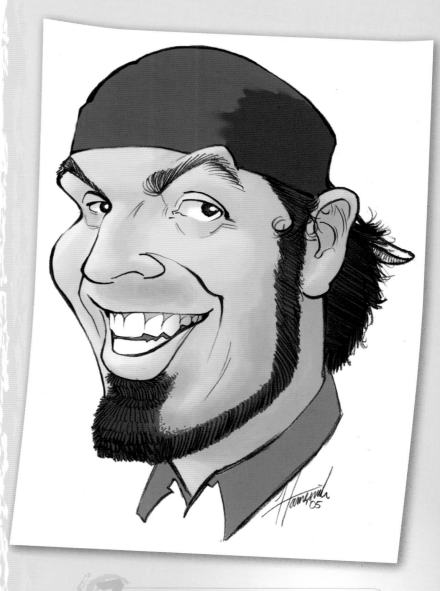

7 Color the sketch using only flat tones. Doing this creates a great TV cartoon look. Add some basic blending and shadows. Remember, if you're working on a computer, you have to scan in the drawing and print it out. This can add a lot of time to each sketch. Working fast keeps you from coloring in a highly realistic way, which is the opposite of what we are trying to learn.

Eye Bags or Smile Lines?

We draw both of these; the difference is that we emphasize eye bags while we merely suggest smile lines. Eye bags tend to stick around no matter what the expression. Smile lines show up when you smile.

Clothing and Decorative Lines

There will be moments when you encounter elements that challenge the formula. Turtlenecks are not difficult, and neither is any other item of clothing. Think of it like hair: Get the inside shape and the outside shape. The remaining lines are just decorative.

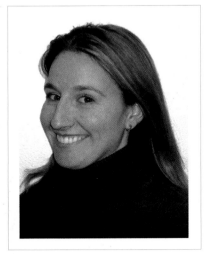

Our Model

1 Start at the eyebrow and work your way down. By now, it should be feeling like a process. Stick to it and you will improve at a rapid pace. Complete an entire sketch; then go and practice the parts you didn't like.

2 Draw line 1 of the hair and then line 2. Add the decorative strokes. Notice how the direction of the hair changes in the section that is tucked behind the ear.

3 Draw the nose. Be kind if you wish when drawing the "bump" on a woman's nose, but make sure you draw it. Leaving it out will make it difficult to get a likeness of the person.

4 Draw the eyes. Remember the process: eyebrow first, eye opening next, then the iris and finally the eyelids. Add lashes at the very end. Match the eyelash type of your subject. Never change it.

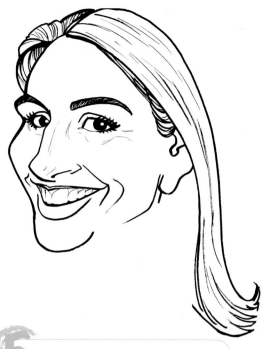

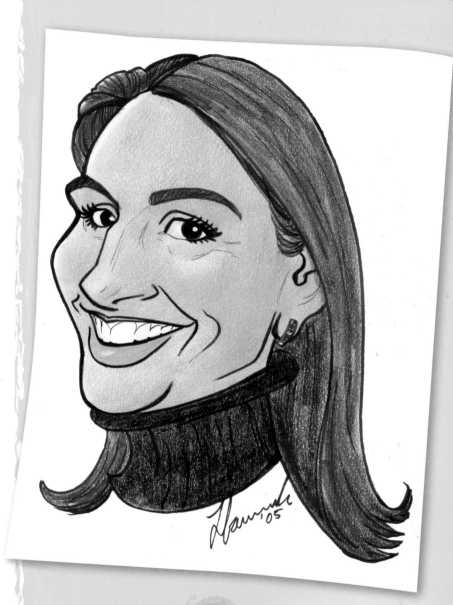

5 Draw the smile. Use caution with the smile lines. The longer the lines, the older the person will look. Draw the gums if they show.

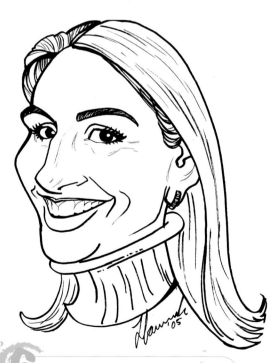

6 Finish the drawing by adding a neck and turtleneck collar. Draw the main lines that describe the collar, then sparingly add a few decorative lines to it. Always double-check to see if you missed anything, such as jewelry.

7 Color the sketch. Remember to color quickly when using colored pencils. Comic portraits are designed to be completed quickly. You model will get impatient if you take too long.

Simplify Minor Elements

Always simplify patterns and details of clothes. These things do not increase the likeness of the drawing.

Analyzing Face Shapes

When you see a friend from far away, you recognize the person by the silhouette shapes of her face and figure. The face shape is very important to the design of a caricature. Go back and look at the first step in each of the drawings of this chapter. See how different they are from each other?

Our Model

1 Start with that face shape. Use only "C" curves, "S" curves or straight lines—no sketchy or messy lines allowed. Compare the placement of the eyebrow to the placement of the cheek and the chin.

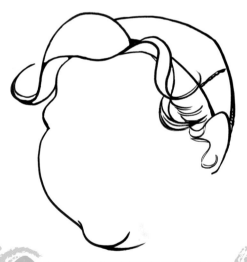

2 Draw the hair lines. Draw complex hair in sections. Draw the bangs first, then the handkerchief; the decorative strokes should always come last.

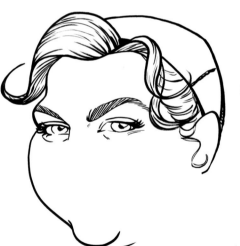

3 Draw the eyes. So much for our streak of drawing the nose first, as we did in the previous two demos! Once you're comfortable with caricatures, you can change the order of how you draw. But pick a formula you like and stick with it for one hundred sketches at a time instead of changing your formula from drawing to drawing.

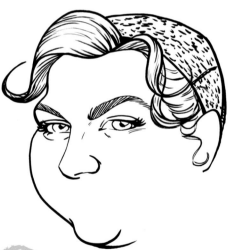

4 Draw the nose, keeping it simple. Forget about the shadows. Sketch in a linear and graphic style.

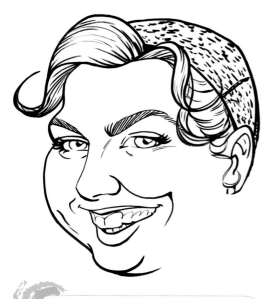

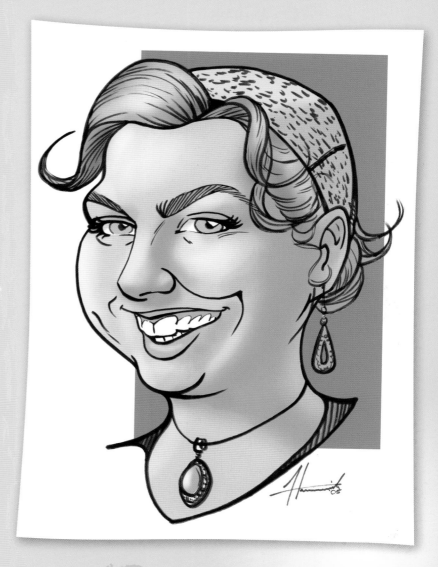

5 Draw the mouth. Remember to look for the anchor and pivot points. The smile lines reveal just as much personality as the other lines of the face.

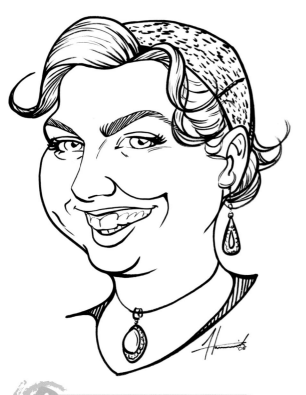

6 Complete the sketch. Enjoy adding details to jewelry or patterns on the clothes, but move quickly.

7 When coloring digitally, color as fast as you can. Color all sketches with the same color palette. It's a stylized art form, not realism.

Using Pencils Like Markers

When sketching in pencil, use the same approach as you do with markers. A good pencil has a wide lead and can draw light and dark without smearing a lot.

Our Model

1 Start as you usually do, but sketch slightly smaller when using pencils. Pencil tips are smaller than markers, so be sure to adjust for that.

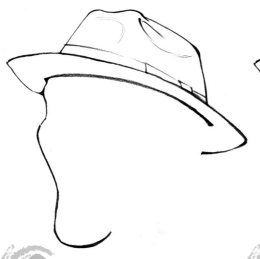

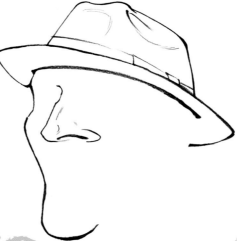

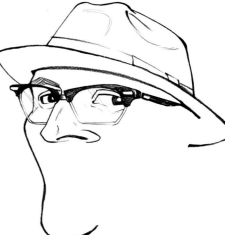

2 Drawing hats is no different than drawing hair. Draw around the face first, then the outside shape. Finish with the decorative details.

3 Noses on men are fun to draw. Exaggerate this feature as much you want on men. They can usually take it.

4 Always work in the biggest sections first. Because the glasses take up more room than the eyes, draw the glasses before the eyes. Make sure they rest on the nose properly. Glasses can change the position of the eyes on the face. Place them how you see them, then add the eyes.

5 Draw the mouth and the sideburn. Then add the five o'clock shadow, filling it in with matching directional strokes (see sidebar). If you change the angles as you go around the face, it will look like a beard instead.

7 Graphite and colored pencils don't mix very well. I recommend computer coloring a pencil sketch, if you color it at all.

6 Finish the ear and hair, then draw the neck. Necks can be very funny, so experiment a little and see what results you get. An elongated neck fits this caricature perfectly.

Matching Directional Strokes
Matching directional strokes means you should draw all the lines going in the same direction, with the same distance between them.

Mastering Facial Hair

Facial hair can be shaggy or groomed, light or dark, thick or thin. Be sure to pay attention to the color, texture and type of facial hair, and how it varies on different areas of the face.

Our Model

1 Draw the profile line of the face. Add the jaw by describing the hair texture, color and volume.

2 Add the beanie. Go around the face and then add the silhouette shape. Draw the details of the hat one row at a time.

3 Draw the nose. Features that are not the focal point in your sketch should be kept simple. Draw them smaller so you have more room to exaggerate the other features.

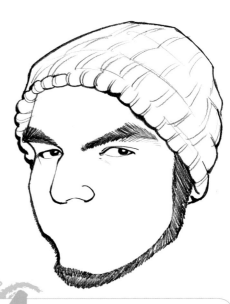

4 Pay attention to the negative spaces created when you add the eyes. Look at his left eye. See the space between the eyebrow and the beanie? Spots like this are good anchor points to use.

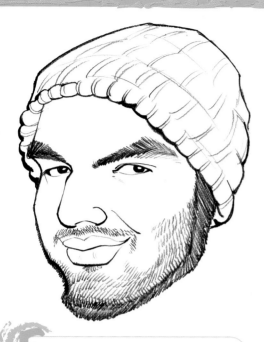

5 Draw the mouth. A lot of subjects don't want to show their teeth, but don't be fooled: Only one in ten actually smile without showing their teeth. The facial hair is thin on much of the face and the moustache, so add it with fewer and thinner strokes.

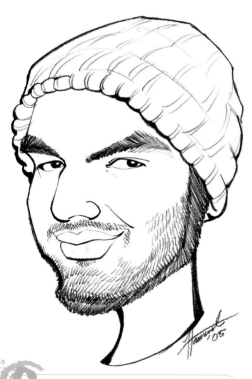

6 Keep the neck simple and collarless when your sketches are getting too busy or are taking a long time to finish.

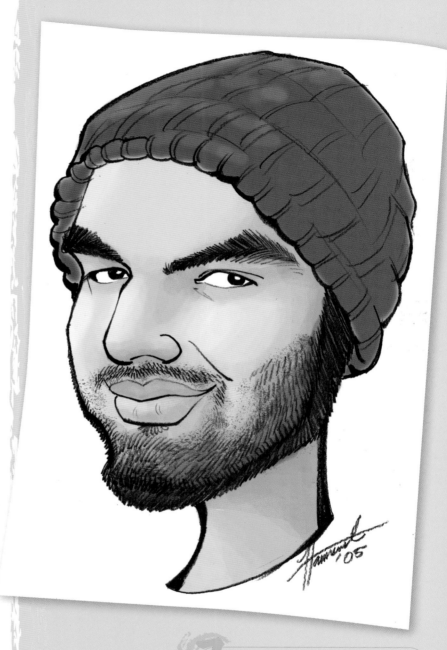

7 When coloring the sketch, you can add a subtle hint of light blue or light gray to enhance a shadow area. Color the beard according to what you see.

Hair Strokes

To draw shaggy hair, use long "C" curves. To draw hair of a light color, use thin lines. To draw dark hair, use dark strokes. To draw thick hair, leave less space between your strokes.

Watching Your Head Shapes

Take time to draw the head shape accurately. Short hair describes the head in a particular shape. Hair strokes can be very difficult to control and can disrupt the head shape, so remember to add a light guideline to help you stay on track if you need it.

Our Model

1 Look at your model for at least ten seconds. Position his head where you need it to be. Think about the profile line you are going to draw as you're looking. Draw the line when you are sure of what you want to draw.

2 Draw short hair with care. Short hair closely follows the head shape. If you mess up, your mistake will be obvious.

3 Draw the eyebrows using the same principles that you use with hair. They have texture, color and volume. As for the eyes, remember that the larger the iris, the younger the person will look. Think Bambi.

4 Draw the nose plainly and simply. The nose is the measuring tool for ¾-view caricatures. Reposition your subject if he moves by rotating him until you can see only one nostril.

5 Add the mouth and smile lines. Add lips, but keep the lines thin on men or they will look like lipstick.

6 Finish with the ear and neck. Always review to be sure you did not miss anything.

7 Add the color. A simple sketch that is colored well stands out without any frills.

Avoid Bed Head

When you mess up the head shape with short hair, the result is a deformed head or one with "bed head."

Hair Covering the Face

When hair covers the face, draw it as you see it. If you cannot see the features, then draw the hair first. If you can see the features, continue as you normally would, then add the hair over the features.

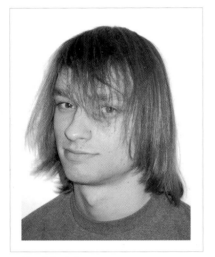

Our Model

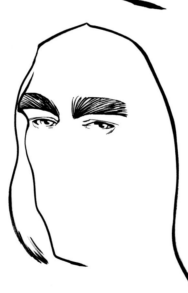

1 Draw the profile line. Notice the angle of the face and the very subtle variations in the line.

2 Look at our model on the next page. See how we can see his features through his hair? Skip line 1 of the hair and draw line 2. We will add line 1 later.

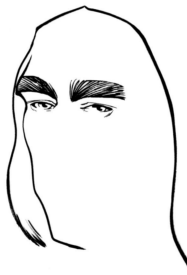

3 Add the eyes. The eyebrows can be more interesting than the eyes themselves. Enhance one or the other.

4 Add the nose. Be sure not to make all features big, even when you are tempted. Pick the best one and go with that. The hair is our focus here.

5 Draw the lips. You can contrast one against the other by making one very thin and the other very thick.

6 Finish the sketch. Add hair line 1 first, then the neck and collar. Draw the hair right over the features. Mix the decorative strokes in with line 1.

7 Color the sketch. Color the hair over the features; you will still be able to see them. The fact that his hair is transparent adds to the effect. Note the cast shadow on the neck; it's the same on all sketches.

Unify Multiple Lines

When you have a lot of lines in a sketch, you can create a heavier outline to unify the drawing and anchor it to the page.

Color Enhances Ethnic Faces

Pay close attention to different ethnicities. Capture the correct look based on what you see, not what you think you know. The color will then enhance your drawing.

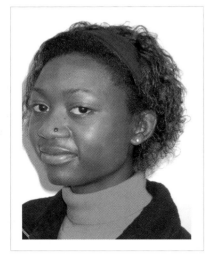

Our Model

1 Draw the profile line. Add the jawline if it is well defined.

2 Draw line 1 of the hair. Notice the texture and volume. Add line 2, breaking it only where there are layers in the hair. Always include hair bands, ponytails or anything else that may be in the hair.

3 Add the eyebrows and eyes. Slow down and take a good look. The eyes speak volumes about a someone's personality. Make the eyelashes match your model's.

4 Draw the nose. Don't be afraid of adding what is already there, such as moles. You don't have to insult them, but they know they have it, so you can add it.

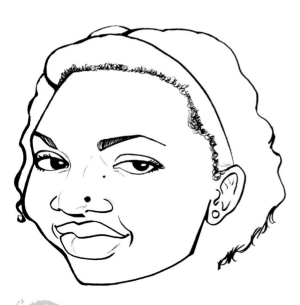

5 Draw the ear and the mouth area. Study the amount of space it occupies between the nose and the chin. Lip lines are thicker when your subject is wearing lipstick.

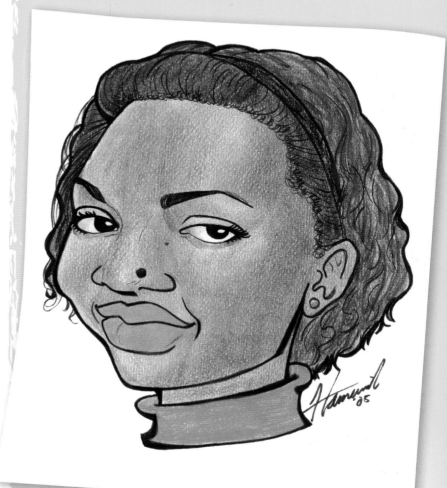

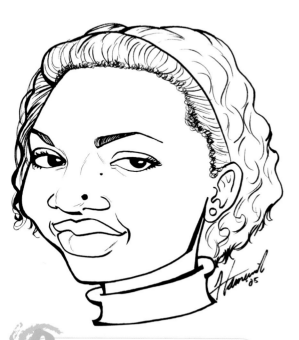

6 Add the decorative strokes and complete the drawing. Notice that the wavy strokes in the hair help define the texture. The strokes tucked into the head band define the subject's bangs.

7 Color the sketch. Use your limited palette, and remember that this is a stylized art form. We are not trying to capture the model's exact skin tone. Notice how dark color makes it hard to see all the decorative strokes we put in earlier. Think ahead and save time by not adding many of those strokes.

Working With a Dynamic Model

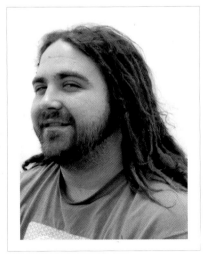

Our Model

1 Draw the profile line. Notice the subtle suggestions of facial hair. Add those after you draw the line.

2 Draw line 1 of the hair, then line 2. Pick one or two dreadlocks of hair, or braids, and add lots of detail to them. You can spend an hour on this if you are not careful, so don't overdo it.

3 Draw the eyes. Add some shadows if you feel confident. Keep the directional strokes consistent so as not to confuse the viewers.

4 Draw the nose. The nose is a great feature for men, but you have a lot to work with on this model, so keep it simple.

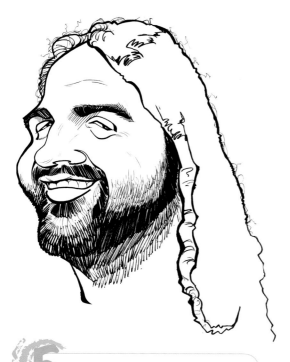

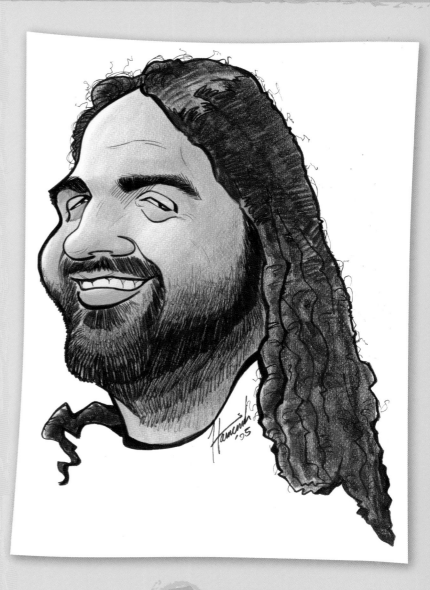

5 Draw the mouth first, then add the facial hair that defines the lower half of the face. Vary the lines and their thickness to create that scraggly look.

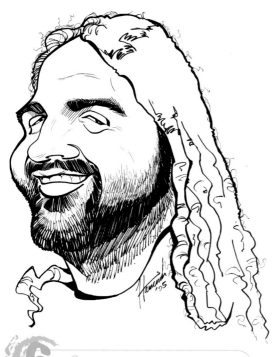

6 Complete the hair with decorative strokes, but not too many. He has darker hair, which you are going to color. Keep the collar simple.

7 Coloring a sketch should be the icing on the cake. It should make a great sketch even better. Don't expect color be the crutch that "saves" your sketch, because it won't.

Enjoy Your Art

Sometimes you draw an awesome sketch but your model may not like it. Don't be offended. Enjoy your art. Keep that drawing you liked for yourself, and redraw your model.

Making Hair a Graphic Element

A good caricature has areas of detail that are cool to look at. For the viewers to enjoy those areas, you need to balance the detailed areas with simple graphic elements. This means you should make areas that are far away from the details as simple as possible. Simple areas do not attract attention. This allows the details to be seen faster because our eyes go to details quickly.

Our Model

1 Use the hair as a graphic element to make the outline of the face more interesting.

2 Drawing line 2 of the hair is simple. Simple shapes will allow the face to attract more attention.

3 Glasses can be added later in the drawing if they confuse you at this point. Ask your subject to take them off until you are ready to draw them. Otherwise, put them in now.

4 The nose fits into its place. Remember, it has to fit with the original cheek shapes you created.

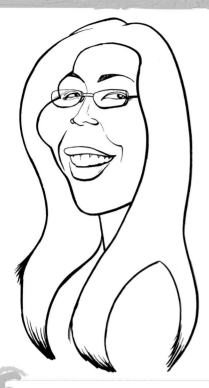

5 You can draw normal-looking features, but changing the spacing of them creates an exaggerated look, as shown here in the distance between the mouth and nose.

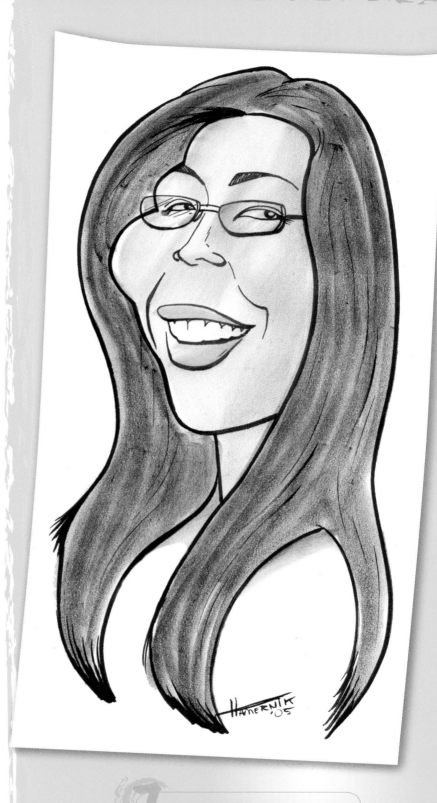

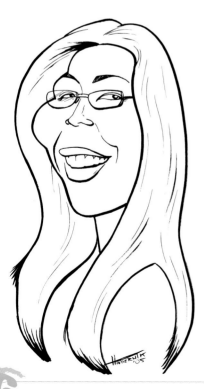

6 Add some decorative lines at the end. Make sure you didn't miss anything.

7 Add some color to your sketch. Hopefully now you've got a handle on drawing ¾-view caricatures.

Drawing Profile Caricatures

Basic Process

This lesson covers the basic pattern you will use for profiles. Follow the same basic formula that you used for drawing front-view and ¾-view caricatures. Keep in mind that a lot of people don't know what they look like from the side, so you may get comments such as "Does that look like me?" Be confident, and don't emotionally attach yourself to your sketches.

Our Model

Every now and then, draw from your imagination. It'll sharpen your perspective... and your skills.

1 Start at the brow ridge and work your way down the profile line of the face. Capture the nose and mouth with the teeth, and stop at the chin.

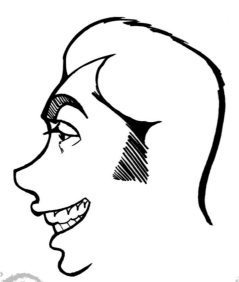

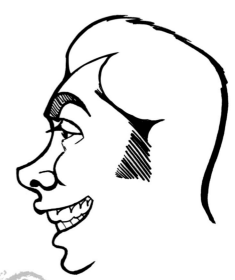

2 Draw up to the forehead, and add line 1 of the hair. Then add line 2 of the hair. The back of the head is a good place to exaggerate the shape; doing so will not affect the likeness too much.

3 Work your way down the face as you draw the features. Start with the eyebrows, then add the eyes.

4 Add the nostril and the cheek.

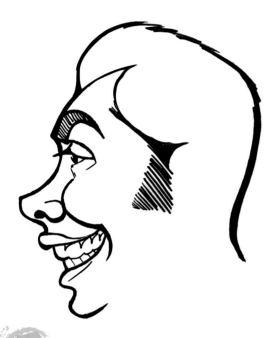

5 In this example, you drew the teeth in step 1, so now just add the lips and complete the smile line.

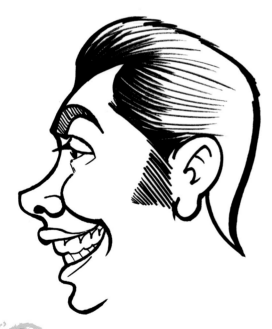

6 Draw the ear and its details. You can add some decorative strokes on the sketch now, if you like.

7 Complete the sketch by adding the neck and the collar of the shirt. Sign it.

Profile Facial Features

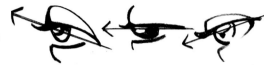

PROFILE EYE SHAPE
Think of the profile eye as the letter "A" tipped on its side.

DRAWING THE EYE
Draw the upper opening, the lower opening, then the eyelids. Next comes the iris, pupil and highlight. Finish with eyelashes, if necessary. Use earlier tips about drawing the eyes (see page 34).

PLACING THE ANCHOR AND PIVOT POINTS
There are anchor and pivot points to the profile eye. Use the upper opening and the back corner of the eye. Notice the angles of each of the examples.

PLACING THE LOWER LID
The lower lid slants in many ways. To get this right, you may even have to lean in for a better look at the eyes on your subject. Ask him to remove his glasses if necessary.

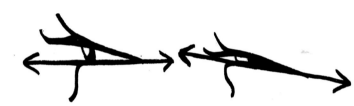

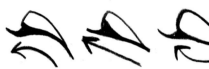

STUDY THE EYE CURVES
The eyes are very subtle. Look closely to see which way the lines curve.

PROFILE EYE COLOR INDICATIONS
They are (from right to left): blue, hazel, light brown and dark brown.

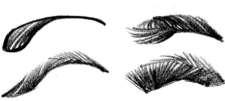

PROFILE EYEBROWS
Eyebrows come in many shapes, colors and textures. They can be groomed or natural, straight or wavy, and light or dark.

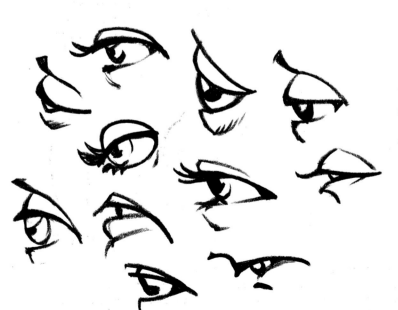

ANCHOR AND PIVOT YOUR EYEBROWS
Look for the angle of the anchor and pivot points. Use the side closest to the profile line as the anchor.

PROFILE EYE SAMPLES

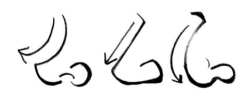

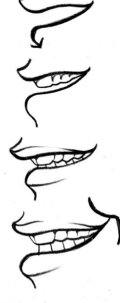

DRAWING PROFILE NOSES

Pay close attention to the swoop of the nose. The nose line can get too long fast, so watch that length.

WORK DOWN, NOT UP

Work your way down the shaft of the nose. Pushing the marker up the page when drawing the profile nose will seem awkward.

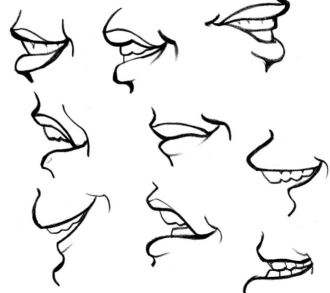

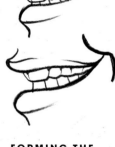

FORMING THE PROFILE MOUTH

The mouth will be part of the profile line. Work your way down and into the mouth. Break the line only when necessary. The teeth, lips and smile lines should be done last.

PROFILE NOSE SAMPLES

PROFILE MOUTH SAMPLES

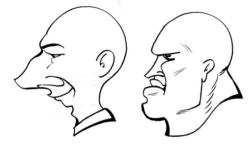

ADDING A NECK

The neck will have a huge effect on the drawing. Keep in mind that a large neck on a woman will make her look like a football player.

DRAWING THE HAIR IN PROFILE

Hair line 1 creates the facial area. Hair line 2 creates the silhouette of the caricature. Decorative strokes should always be added last.

PROFILE LINE AND HAIR SILHOUETTE ARE THE KEY

Notice how just the profile line and the silhouette of the hair make the caricature? The features come second to these two lines in a profile sketch.

Adding Facial Hair

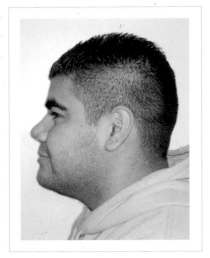

Our Model

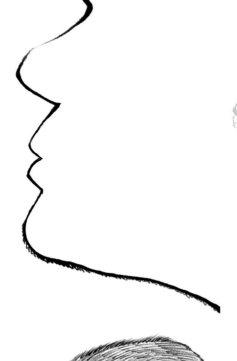

1 Draw the profile line in one stroke if you can, starting at the eyebrow ridge and working your way down the face. If you need to break up the line, first draw the brow, nose and upper lip; then add the lower lip, chin and jaw. Eventually, you will be able to draw it all as one line. Draw thin facial hair after the jawline.

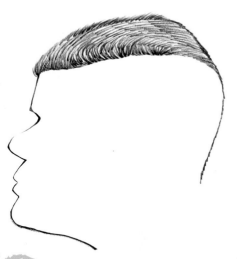

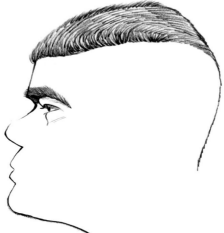

2 Draw line 1 of the hair. Add the second line of hair all the way to the neck. Complete each section before moving on, if it is complicated.

3 Draw the eye area. Remember, the eye is like the letter "A" tipped on its side. Complete the whole section before moving on. Being thorough as you go will save a lot of time.

4 Draw the nose and the cheek. Pay close attention to those anchor and pivot points. These will help you know how to exaggerate. Use thicker lines for big cheeks.

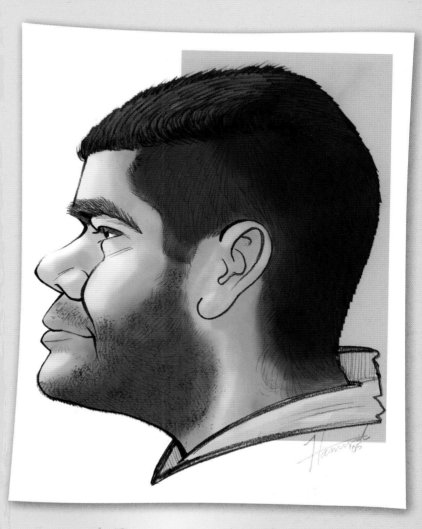

5 Add the mouth. (For tips on drawing the mouth in profile, see page 101.) Add the facial hair in the direction that it grows. If it is only a shadow, use decorative strokes drawn at the same angle.

7 Add the color. Remember not to add many decorative strokes in the hair when you are going to color it dark. This will save you a lot of time.

6 Complete the details on the hair and add the ear. Draw in the jawline. A strong jawline will curve up toward the ear. A weak one will curve down into the neck and the collar. For hair that fades, spread out your lines and fade it as you see it on the model.

Adjusting the Process

If you have followed each section of this book, by now you should instinctively be able to adjust the drawing process according to your model. These processes are not set in stone, but are flexible designs meant to teach you the basics.

Our Model

1 Draw the profile line of the face. When you get a good smile on your model, add it as you work your way down to the chin. Draw the mouth opening, teeth, gums and smile lines. You will come back to the mouth area in a few steps to finish up anything you did not do here.

2 Add line 1 of the hair. Break the line up into sections if you have to. Now draw the silhouette of the head. Add everything you see, making decorative strokes at this time if you prefer. When working in pencil, remember that your drawing hand may smear it if you are not careful.

3 Add the eye area. Look for the angles. Use a thick line to emphasis the most important section. Add lashes to women, not to men or boys.

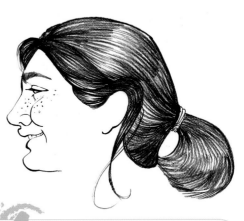

4 Draw the nose area and the cheek. Look for freckles or any other permanent markings. Add nose rings or other facial piercings if your subject has them.

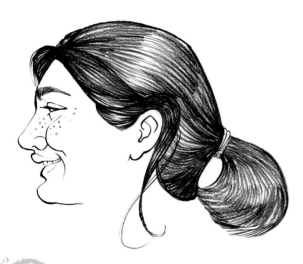

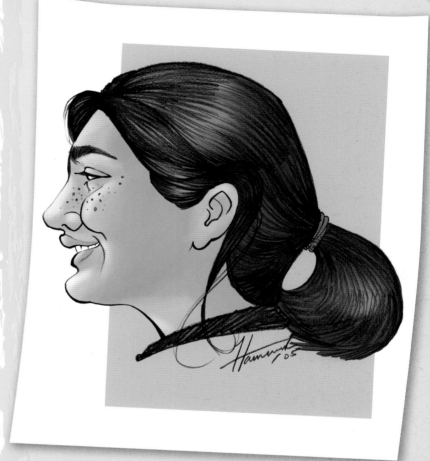

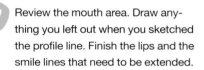
Review the mouth area. Draw anything you left out when you sketched the profile line. Finish the lips and the smile lines that need to be extended.

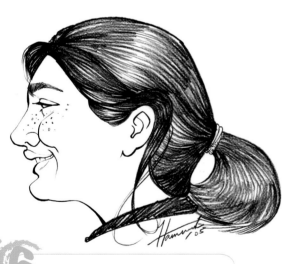

Add the neck line, collar and anything else that you may have missed.

Color the sketch. Figure out a coloring process for yourself and color in the same manner every time. For example, I always color the skin tone from top to bottom, left to right. Leave the highlight areas white or very light. After I finish the hair, I add details such as eye color or a subtle shadow under the chin.

Plan Your Page
Be sure to leave enough room on your paper for the entire head. Don't center the eyebrow on the page or you're likely to run out of space for everything else.

105

Varying the Profile Line

You always begin a profile sketch with the profile line, but that line and the angle of it can have countless variations. The profile line of the face reveals the most amount of character. Draw what you see, but design the strokes. Lines should be straight ones or simple "C" curves. Square shapes need to be made more square; round shapes need to be made rounder. This is the method I use to simplify what I see.

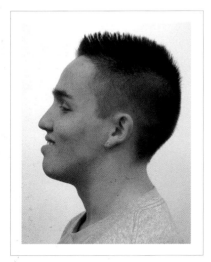

Our Model

1 Draw the outline of the profile. Flip through the book and compare this step with the first step of each demo. See the difference? Design each stroke.

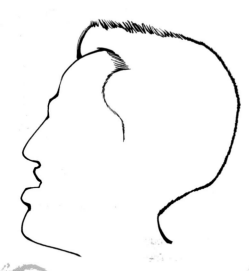

2 Draw lines 1 and 2 of the hair to set up the rest of the sketch. Enhance head shapes for a more interesting sketch; changing the proportions of the back side of a person's head will not affect the likeness too much. You could shorten the back and make it a tall, skinny head, or lengthen the back to create a huge cranium.

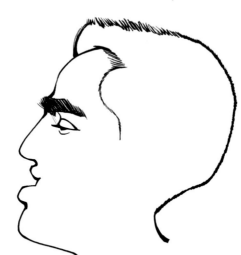

3 Draw the eyebrow and eye shape. If you can't see parts of the eye, don't draw them. If a person doesn't have large eyes, emphasize other areas of the face.

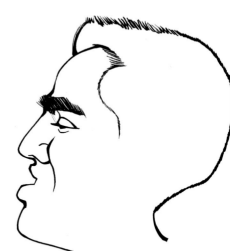

4 Add the nostril and cheek using your anchor and pivot points. Notice the distance between the nose and the upper lip? Capturing this characteristic will help the resemblance between the drawing and your subject.

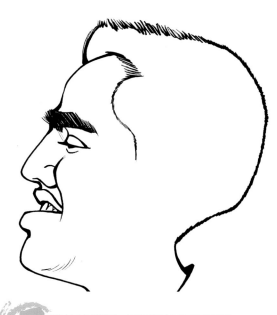

5 Try to capture the mouth characteristics. The lips are large, but there will be no mistaking it for lipstick on this face. It fits in perfectly.

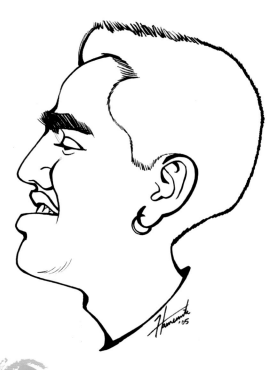

6 Complete the sketch, adding the Adam's apple. Go with what you see. The eyes, nose and mouth are not the only features that you can emphasize.

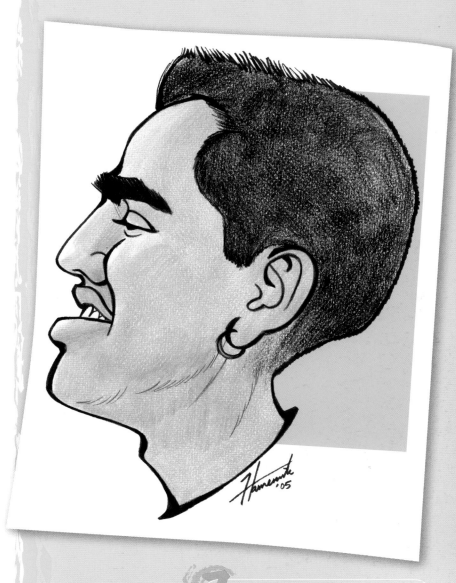

7 Color the sketch as you normally would. Background colors and shapes should not compete with the sketch. As a rule of thumb, don't let the background shape cut through the profile line.

Styling Short Hair

When drawing very short hair, draw the head shape with the thinnest and lightest line you can draw. Then go over it with the hair strokes. The first line will help you get the correct shape; the second will help you focus on getting the hair right.

107

Drawing a Complex Profile

Occasionally, you will get a model with a very complicated profile line. Slow down and tackle each section individually. First, study your model closely and establish the overall angle of the face. Ask the person to hold completely still for a minute so you can draw him accurately. Your model wants the sketch to look good as much as you want to draw a good sketch.

Our Model

1 Plan carefully and establish which features stick out the most or the least. Relate everything else to those points. The eyebrow and the nose can provide the anchor points for the rest of the profile line. Here, we start with the top of the nose because the brow will be hidden by the man's hat.

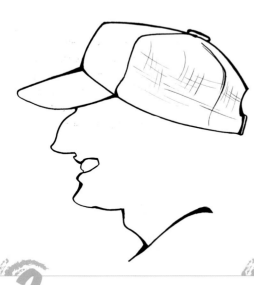

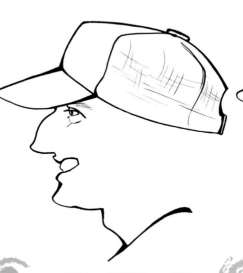

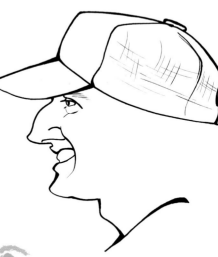

2 Draw the hat as the hair line. Memorize how to draw hats. I never copy what I see on the model; I use the hat I have memorized. Drawing the hat perfectly won't make your sketch look more like the person.

3 Add the eye area. Draw only what you can see. If you can't see the eyebrow, leave it out. You can only see part of it on this model. Be sure to get the eye color indication correct (see page 100).

4 Draw the nostril and cheek line. It's plain and simple if you follow the anchor and pivot points you've established.

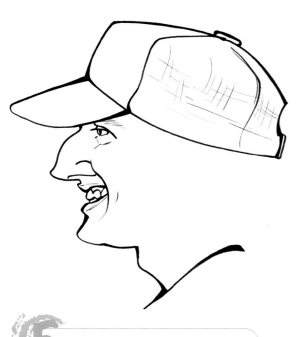

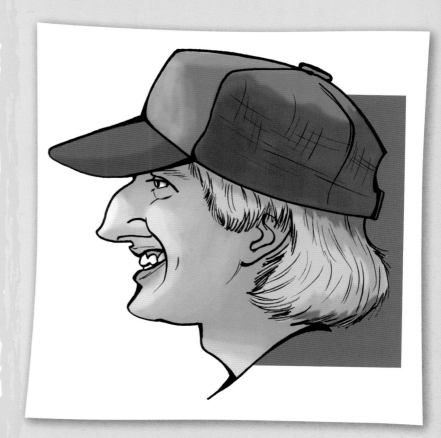

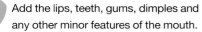
5 Add the lips, teeth, gums, dimples and any other minor features of the mouth.

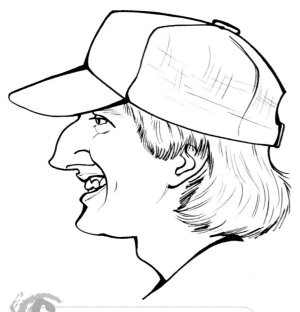

7 Add the color. Color your sketches using the same approach every time. Don't be afraid to ignore cast shadows and directional lighting and use idealized lighting instead. The only shadow I routinely add is the one under the jaw.

6 Add the hair and the part of the ear that shows. Draw the hair color, volume and texture correctly. Notice that the neck was completed in step 1 when we established the most and least prominent features of the face (his Adam's apple is pretty noticeable).

Using Heavy Pencil Lines

When sketching with markers, you can easily achieve different line thicknesses. In pencil, you have to go back over and thicken the lines where you want emphasis. Be sure to keep it stylized—don't start sketching realistically.

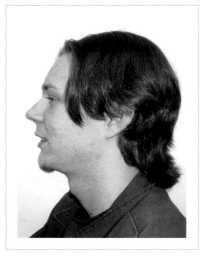

Our Model

1 Draw the profile line. Think about how much room you will need for the rest of the head. Go back over and thicken any areas that you want to emphasize.

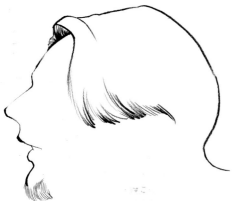

2 Draw line 1 of the hair. "Line" 1 does not mean it is made up of one continuous stroke. Use as many as you need to get the look of the hair. Line 2 is a simple shape. Break up the hair line (in this case, near the forehead) to show the length of the hair.

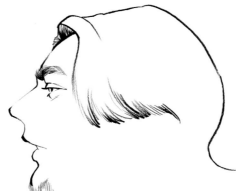

3 Draw the eyebrow, following the direction that the hairs grow. Then add the eye.

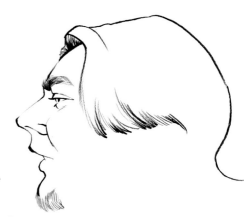

4 Add the nostril and the cheek line. Notice that the same line has been used on every profile sketch so far. What changes is the angle and the distance.

5 Draw the mouth. If the model has very small lips, you can leave off one or both of them. This is another form of exaggeration.

6 Finish the sketch by completing the hair shape first, then the neck line and the collar. Add any decorative strokes last.

7 Coloring a sketch that you really enjoyed drawing makes it even more rewarding. Practice doing black-and-white sketches until you are really comfortable with them before you start coloring them.

Savor Stray Lines

There may be stray lines in your sketch that you want to erase. Leave them. Part of the look of quick comic portraits is that they are spontaneous. I don't carry an eraser. If you make that big of a mistake, start over.

Varying Your Pattern

Stick to your basic profile-drawing pattern as much as possible. However, subtle variations are inevitable, which is OK. For example, in this demonstration, as with a few others you've seen in this section, you will develop more of the mouth in the first step.

Our Model

1 Draw the profile line and some of the mouth. The mouth shape here is very simple. In this case, it was easier to develop parts of the mouth at this point rather than skip it.

2 Move onto lines 1 and 2 of the hair. Be careful not to get a lumpy head shape as you draw line 2. Buzz cuts can be tricky, but they are simple with a little practice.

3 Add the eyebrow and eye. Draw the eye larger if you want the subject to look younger. Make it smaller for older subjects.

4 Draw everything as simply as possible. Draw the nostril with just one stroke in this case. All the lines should naturally fall into place.

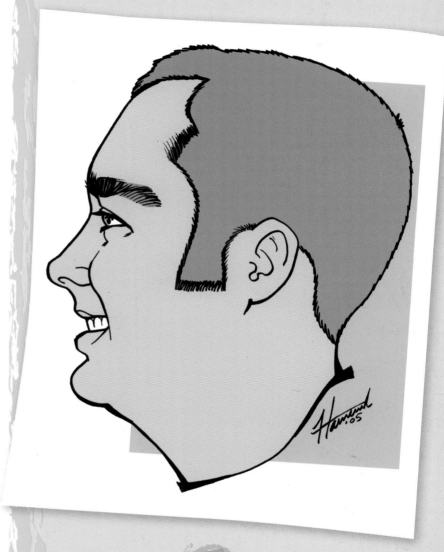

5 Finish the mouth with simple, thin lip indications. Heavy lines around the mouth will look like lipstick.

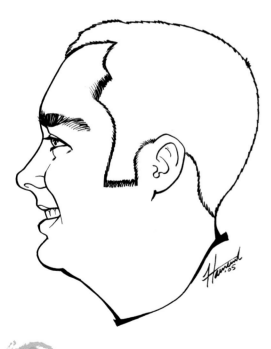

6 Finish the ear and neck line. Make your sketches fresh and clean-looking by not overdrawing them. Once you complete the pattern, you are done. Sometimes there is no need to go back and add any more strokes.

7 When in doubt, keep your colors simple. Overcoloring a bad sketch will not improve it. Even flat tones will look great on a good sketch.

Sharpen Your Drawing Skills

The drawing will always be the king. Spend time honing your sketching abilities. Coloring and finishing drawings may be fun, but they should be the icing on the cake.

Drawing Long, Long Hair

Long hair can be really challenging, so plan ahead. If you want to draw all of the hair, you will have to draw a much smaller head so that it all fits. If you are sketching with a thick marker, a small head may be hard for you to draw. On the other hand, if you are drawing with a thin pencil, drawing all that hair may take a long time. And remember, you will have to color it all in later. Consider these things before you set out to draw.

Our Model

1 Start with the profile line. You can incorporate the forehead with this line if you like.

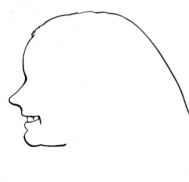

2 For very long hair, draw line 2 of the hair first so you will know how much hair will actually fit on the page. You can also compare it to the head to get the right look you are trying to achieve.

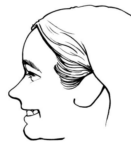

3 Add line 1 of the hair. Include the ear as part of line 1. Draw the hair in sections, adding some decorative lines as you go. Draw the eye next.

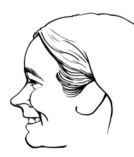

4 Add the details on the nose and the cheek line. Watch for overlaps such as the cheek and the nostril. Double up the smile lines, too.

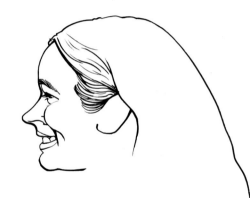

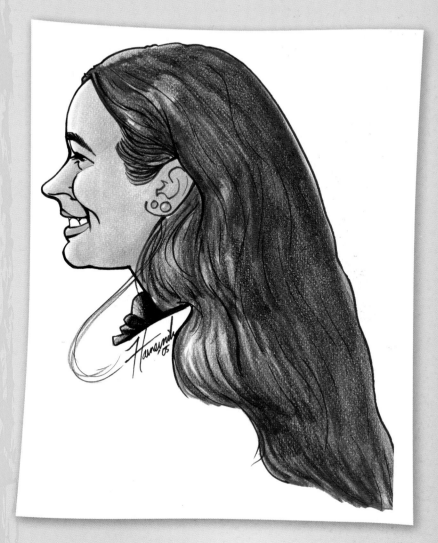

 5 Add lips to the mouth. This should be the only thing you have left to add to the mouth area at this point.

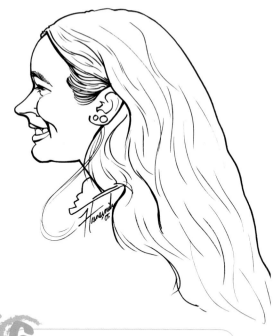

 6 Finish the hair by adding decorative strokes. Remember, the hair will probably end up being the most important part of the sketch. Complete the sketch by drawing the neck and collar.

7 Color the sketch. Because the hair is the focal point, put more details into the coloring there.

Losing the Long Hair

If you want to de-emphasize the hair, rotate the model to a ¾ view or front view.

Long Hair on Men

When your male model has long hair, you really have to nail each of his facial features. Hair can be like eyelashes, a feature that could make your model look more feminine. Pay close attention to the style of the hair as well. Men wear their hair differently than women do.

Our Model

1 Start with the profile line. Use thicker lines to make the profile stand out more than the hair. Try to especially emphasize the nose and chin.

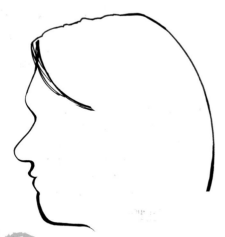

2 First draw line 2 of the hair, until you reach the ponytail holder. This subject's hair does not have a lot of volume, so it will define the head shape pretty well.

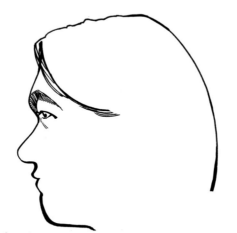

3 Add the eye area. The anchor and pivot points on Asian eyes vary a lot. The tear duct is also very important to their character. As you gain experience, you will notice that certain ethnic types have common characteristics. Asian eyes, in general, slant in this way, and the tear duct is more predominant than in other ethnicities.

4 Draw the nostril and cheek. Sometimes the nostril opening is very visible, so draw it this way. You can be nice and still draw what you see.

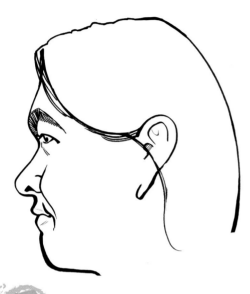

5 Add the lips and smile lines around the mouth. Add the ear shape if you didn't add it with line 1 of the hair.

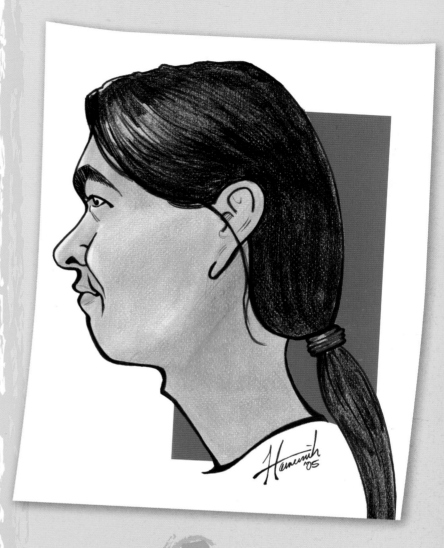

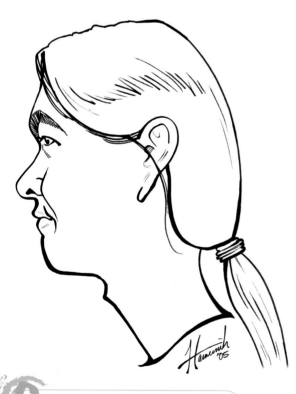

6 Finish the sketch. You can shed some of the hair to take the emphasis off of it. The neck is a great feature to have fun with on sketches of men.

7 Another way to use color is to help attract attention to the area you want the viewer to see. Use flat tones on areas you want to de-emphasize, while adding basic shadows and highlights to areas you want the viewer to notice.

Dramatic Examples

Check out more dramatic exaggerations and coloring in the Celebrity Gallery starting on page 120.

Full-Figured Subject

You will meet all types of people while you are drawing caricatures. Always remember that they are choosing to sit in your chair. They know what they look like. Don't think twice, just start drawing your pattern. When drawing full-figured subjects, the neck is an important part of the sketch. Compare where the neck lines up in relation to the other features. This will be important for capturing a likeness.

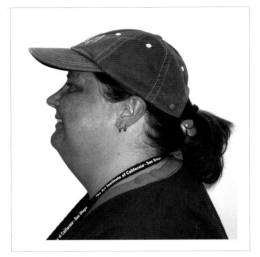

Our Model

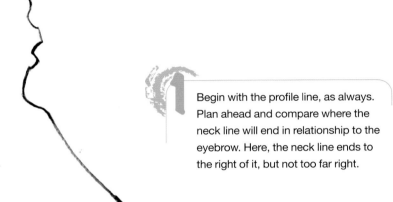

1 Begin with the profile line, as always. Plan ahead and compare where the neck line will end in relationship to the eyebrow. Here, the neck line ends to the right of it, but not too far right.

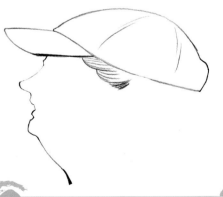

2 Hair lines 1 and 2 are made up of the hat lines. Add the hair where it shows under the hat, toward the ear.

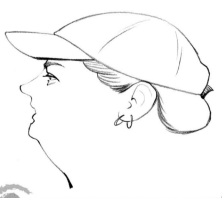

3 Develop the hair and add detail to the ear. Then add the eyebrow and eye, and work your way down the face.

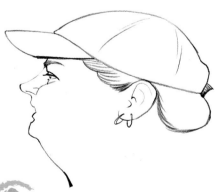

4 The nostril and cheek line are easy to draw; however, note how the cheek covers the nostril a bit.

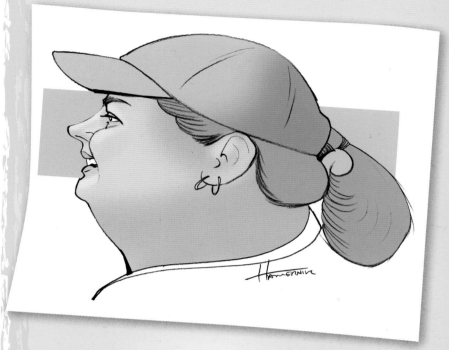

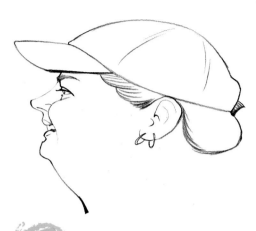

5 Catch all the details of the mouth, including any quirks. These quirks give the sketch character.

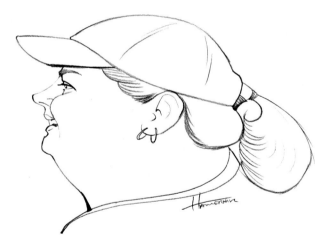

6 Finish the hair by including the ponytail that extends from the back of the cap. Then add a simple collar.

7 Normally, extending the background shape past the profile line is unnecessarily distracting. But, you can place the background shape this way purposely to attract attention to a certain spot on your drawing.

KEITH RICHARDS

JESSICA SIMPSON

ANGELINA JOLIE

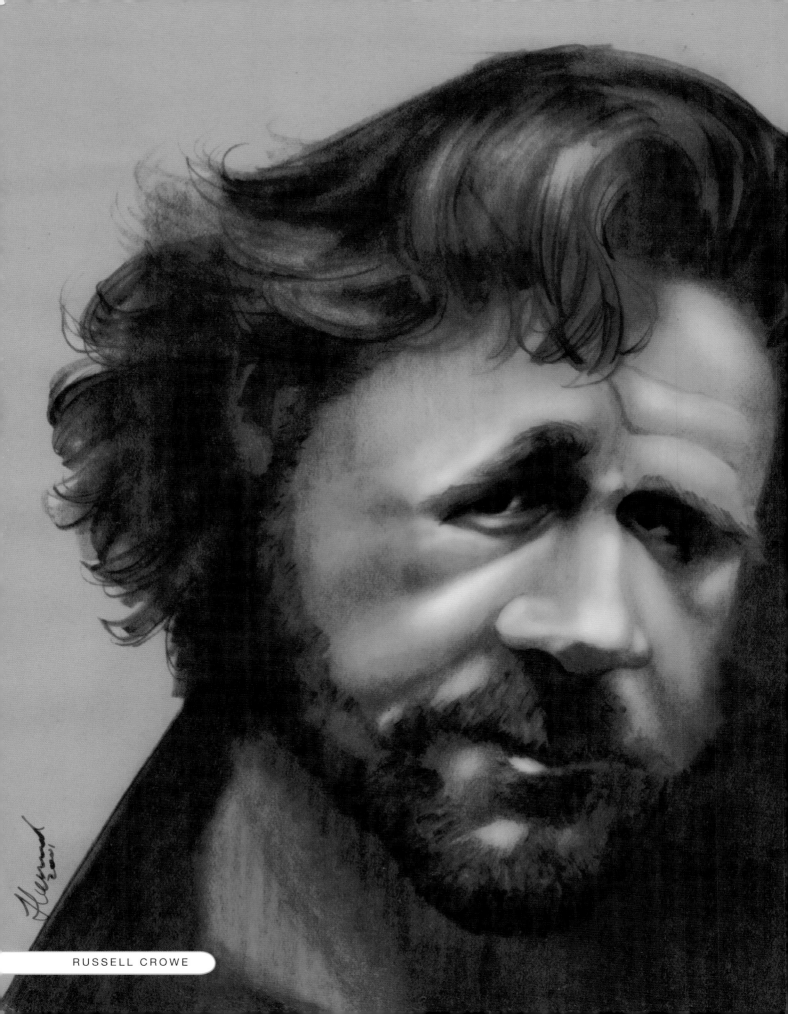

RUSSELL CROWE

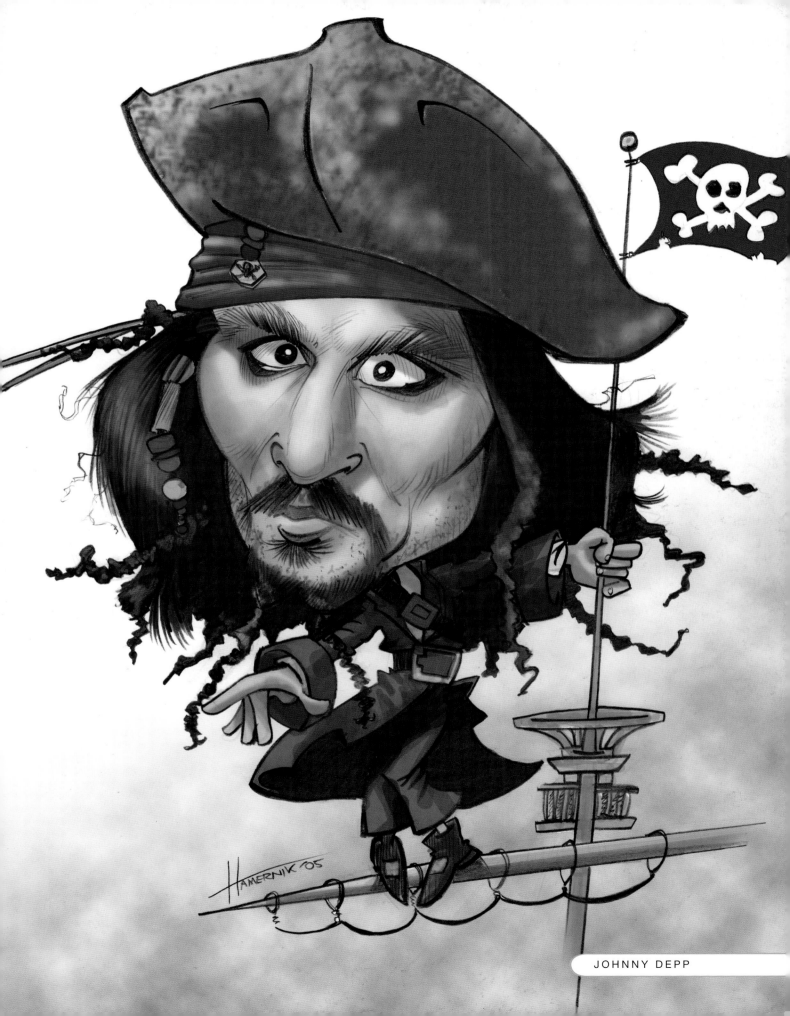

JOHNNY DEPP

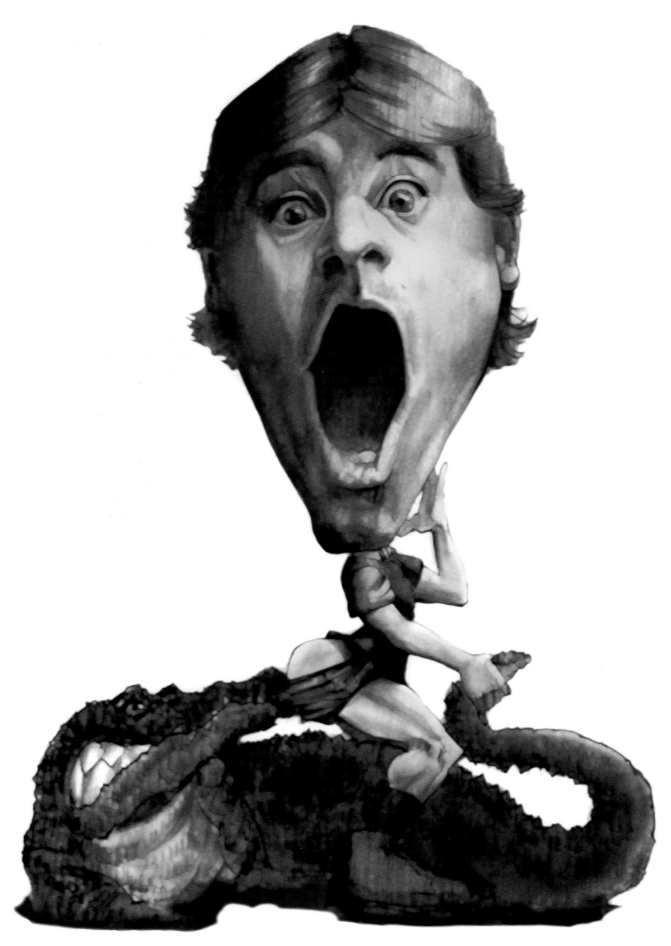

STEVE IRWIN, THE CROCODILE HUNTER

Closing Comments

Congratulations! You made it through the book. Now go back through it at least three more times. You will pick up a lot by reviewing it over and over.

Stick to the pattern or order that you use to draw each caricature. By sticking to the pattern, your sketches will be completed quickly, and it's less likely you will forget to draw something. Once you are completely comfortable with the pattern and have drawn many people using it, begin experimenting. Change the pattern to what fits you better. Establish your personal pattern and stick to it.

Enjoy your new skills. Caricatures are great for entertaining at parties and gatherings. Have fun! When you are ready for more, go to www.hamernikartstudios.com. There you will find additional information about drawing exaggerated faces, adding bodies to your caricatures and working in color, and other extra tips. You can e-mail me with questions at info@hamernikartstudios.com.

Harry

Closing Tips

✗ Thick lines attract more attention than thin ones.
✗ Angular lines are masculine.
✗ Curved lines are feminine.
✗ On men, focus on the jawline and nose.
✗ On women, focus on the eyes and lips.
✗ Eyelashes are feminine.
✗ Position and reposition your subject how you want them.
✗ Have a pattern or order of drawing and stick to it.
✗ Your "live" caricature should not take more than five minutes for the face.
✗ Practice, practice, practice!
✗ Draw a thousand bad caricatures, then draw only good ones.
✗ Caricatures make great gifts.

Show Me What You've Learned

Here are photos of me. Send your best caricatures of me to info@hamernikartstudios.com.

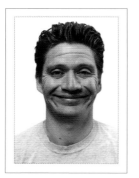 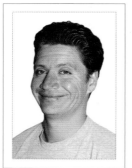 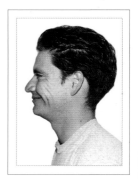

Index

A

Adam's apples, 107, 109
Age, indicators of
 children, 44-45
 ears, 40, 44
 eyes, 112
 irises, 34, 88
 necks, 41
 smile lines, 37, 47
Anchor points, 26-28
 ear, 40
 eye, 26, 32-33
 eyebrow, 32
 facial, 28, 86
 mouth, 36, 68
 nose, 27, 30, 67
 profile, 100, 102, 108
 ¾-view, 67-68

B

Backgrounds, 15, 20, 51, 119
Blending stump, 6, 11

C

Cheat views, ¾-, 52-53
Cheeks, 22, 25, 28, 102
Children, 44-47, 50-53, 56-67
Chins, 22, 28-29, 49
Clothing, 15, 23, 47, 80-81
Color palette, 7, 12, 83
Colored pencils, 7, 12-13, 16-17, 61, 81
Coloring, 7, 12-15, 45, 49, 53, 95, 117
 backgrounds, 20, 51
 computer, 18-21, 79
 eyebrows, 46
 eyes, 13, 15, 34, 100
 flat, 113, 117
 hair, 13, 15, 17, 20, 39, 103, 115
 pattern for, 14-15
 pencil sketches, 85
 skin tones, 13-14, 16, 20, 92-93, 105

D

Detail, 96
Dimples, 55
Directional strokes, 38, 84-85
Distance principle, 26-27, 33, 97, 106, 108

E

Ears, 22, 25, 40
 and age, 40, 44
 covered, 46, 50
Ethnicity, 92-93, 116-117
Exaggeration, 9, 24, 27, 62
 distance, 97
 eyebrow, 78
 hair silhouette, 74
 head shape, 98-99
 lip, 53
 mouth, 37
 nose, 67
 profile line, 74
Eyebags, 42, 78-79
Eyebrows, 22, 24, 32-33, 88, 90
 coloring, 76
 profile, 100
 as shapes, 46
 ¾-cheat view, 52
 well-groomed, 54
Eyeglasses, 58, 72, 84-85, 96-97
Eyelashes, 33-35, 54, 66, 80
Eyelids, 32, 100
Eyes, 22, 24, 26-27, 32-35, 72
 Asian, 116-117
 children's, 44
 coloring, 13, 15, 34
 expression in, 26, 34-35
 and gender, 34-35
 and personality, 92-93
 practicing, 9-11
 profile, 100
 samples of, 35, 100
 sizing, 106, 112-113
 ¾-cheat view, 52
 ¾-view, 64, 66
 variation in, 34-35

F

Face shapes, 25, 28-29, 69, 82-83
Faces
 ethnic, 92-93
 hair-covered, 90-91
 simple, 50-51
Facial features
 exaggerating, 24, 59
 line patterns for, 8-9

 practicing, 9-11
 relating, 46
 simplifying, 86
 sizing, 90
 See also specific feature
Front views, 22-61
 advanced approach, 24-25
 basic pattern, 22-23
 planning, 48-49

G

Gender, characteristics of, 59, 73, 125
 eyelashes, 34-35, 66
 eyes, 34, 59
 face shape, 69
 lips, 59, 89
 necks, 41, 59, 101, 117
 noses, 54, 59, 84, 94
Gums, 37, 81

H

Hair, 38-39, 48, 62, 72
 buzz-cut, 112-113
 cheat-view, 52
 coloring, 13, 15, 17, 20, 38-39, 103, 115
 complex, 82
 covering faces, 90-91
 curly, 58
 dreadlocked, 94-95
 emphasizing, 96-97
 long, 55, 96-97, 114-117
 ponytail, 54-55, 104-105, 116-119
 profile, 101
 short, 88-89, 106-107
 strokes for, 76, 80, 87-88
 textured, 58
 ¾-view, 70
Hair, facial, 94-95, 102-103
 beards, 28-29, 60-61, 78-79, 86-87
 chops, 29
 five o'clock shadow, 85
 goatee, 22
 moustache, 36
Hats, 74-75, 78-79, 84-87, 108-109, 118-119
Head shapes, 88-89, 98-99, 106-107
Highlights, 61
 eye, 33-35, 66

hair, 17, 55
 skin-tone, 14, 16

I
Irises, 33-35, 88

J
Jawlines, 28-29, 44, 48, 56
 bearded, 60-61, 78-79, 102-103

L
Lap easel, 7
Lighting, idealized, 109
Line patterns, 8, 63
Lines
 active, 69
 fuzzy, 8
 multiple, unifying, 91
 pencil, heavy, 110-111
 plumb, 76
 practicing, 8-11
 quality of, 5, 8
 stray, 111
 thickness of, 10-11, 72
 types of, 63
 See also Rhythm lines
Lips, 23, 36-37, 53, 91, 93, 111

M
Markers, 5-6, 8-9, 58, 62-63, 101
Mirror images, 62
Moles, 92-93
Mouths, 10-11, 23, 36-37
 placing, 27
 profile, 101, 112-113
 ¾-view, 65, 68

N
Necks, 23, 41
 angled, 55
 children's, 44-45
 elongated, 85
 full-figured, 118-119
 implied, 75
 line variety in, 53
 male, 59, 117
 profile, 101
 thick, 79

Negative space, 86
Noses, 22, 24, 30-31, 42, 48
 children's, 44, 46
 exaggerated, 67
 female, 54, 80
 length and angle of, 27
 lumps and bumps on, 76, 80
 male, 84, 94-95
 placing, 96-97
 practicing, 9
 profile, 101
 shapes of, 30-31
 ¾-cheat view, 52
 ¾-view, 64, 67
Nostrils, 67

P
Paper, 6
Pencil lead, shaping, 10
Pencil sharpener, 7
Pencils, 6-7, 10-11, 84-85, 104,110-111
Photoshop, 18-21
Pivot points, 26-29
 ear, 40
 eye, 26, 32-33, 100
 eyebrow, 32, 54, 100
 facial, 28-29
 mouth, 36-37
 nose, 27, 30, 67
 placing, 26
Plumb lines, 76
Practicing, 5, 23, 49, 62-63, 69
 features, 9-11
 lines, 8-11
Profile lines, 71, 74-75, 88, 101-103, 106-107
Profiles, 98-119
 complex, 108-109
 facial features, 100-105
 head shapes, 106-107
 line quality, 110-111
 rhythm lines, 71
Pupils, 33-35

Q
Quirks, 55

R
Rhythm lines, 71

S
Shadows, 11, 14, 82, 87, 91, 94-95
Silhouettes, 38-40, 71-72, 74, 101
Sketches
 evaluating, 47
 pencil, coloring, 85
 planning, 105
 starting over, 54, 111
 unifying, 91
Skin tones, 13-14, 16, 20, 93, 105
Smile lines, 23, 81, 83, 114
 and age, 37, 47
 and eyebags, 42, 79
Smiles, 24, 45, 59, 104-105
Stare-downs, 56-57
Strokes, directional, 85
 See also Lines
Symmetry, 28, 56

T
Techniques
 colored pencil, 12-13
 marker, 8-9
 pencil, 10-11
Teeth, 36-37, 79, 87
Texture, hair, 39, 58-59
¾-views, 64-97
 clothing, 80-81
 eyes, 64, 66
 face shapes, 69, 82-83
 hair, 70, 90-91, 96-97
 hair, facial, 78-79, 86-87
 head shapes, 88-89
 mouths, 65, 68
 noses, 67
 rhythm lines, 71
 tilted, 76-77
Tongues, 37, 45

V
Value, 11
Views. See Cheat views, ¾-; Front views;
 ¾ views

If you're going to draw, draw with *IMPACT*

Comic Artist's Photo Reference: People and Poses

Buddy Scalera
ISBN-10: 1-58180-758-9
ISBN 13: 978-1-58180-758-5
Paperback with CD ROM
33425

The ultimate fantasy reference for comic artists! This unique book/CD set is packed with more than 1000 photos of men and women in basic and dramatic poses.

Fantastic Realms: Draw Fantasy Characters, Creatures and Settings

V Shane
ISBN-10: 1-58180-682-5
ISBN-13: 978-1-58180-682-3
Paperback
33271

Discover how to sketch, draw and color your own fantasy worlds! More than 30 demonstrations show you how to invent your world on paper.

Writing Comics with Peter David

Peter David
ISBN-10: 1-58180-730-9
ISBN-13: 978-1-58180-730-1
paperback
33404

Comic writer Peter David (Spider-Man, Wolverine, and Hulk) teaches you everything you need to know about creating comics from start to finish.